GRAVY

ISSUE NO. 83 · SPRING 2022

CW00695833

Contents

FEATURES

26

**WARUNG INDONESIAN
NOURISHES
A DIASPORA**
Kayla Stewart

32

**PURPLE PATCH:
MY HOME AWAY
FROM HOME**
Linda Golden

40

**FROM LATINO ORLANDO
TO INTERNATIONAL
MEMPHIS**
Simone Delerme

2 Editor's Note
Sara Camp Milam

4 Featured Contributors

8 SFA MVPs: Louisville
Lawrence Weeks

10 Good Ol' Chico
Gustavo Arellano

14 The Smoking Section
Hanna Raskin

**18 Even After, Those
Roses Bloom**
Lucien Darjeun Meadows

20 Service Not Included?
John Kessler

52 Back to the Future
Alison Miller

**58 Spellbound in
the Kitchen**
Neely Mullen

**62 Spinning Gold
Out of Chaff**
Annemarie Anderson

66 Last Course
John T. Edge

Gravy is a publication of the Southern Foodways Alliance, whose mission is to document, study, and explore the diverse food cultures of the changing American South.

SARA CAMP MILAM
Editor in Chief
saracamp@southernfoodways.org

BITA HONARVAR Image Editor
bita@southernfoodways.org

RICHIE SWANN Designer
richieswann@gmail.com

**GUSTAVO ARELLANO AND
HANNA RASKIN** Columnists

OLIVIA TERENZIO Assistant Editor
olivia@southernfoodways.org

KATIE CARTER KING Copy Editor

**MELISSA HALL AND
MARY BETH LASSETER**
SFA Executive Staff
info@southernfoodways.org

The features in this issue are published in conjunction with *The Georgia Review* as part of their "SoPoCo" (Southern Post-Colonial) issue, which celebrates the voices, history, and cultures of diasporic communities that have established themselves in the American Southeast since the late twentieth century. *Gravy* thanks *The Georgia Review* for inviting us to collaborate and for their support of these stories. Visit **thegeorgiareview.com** to learn more.

ON THE COVER AND ABOVE: Illustrations by Natalie Nelson

REFLECTIONS ON A DECADE OF *GRAVY*

The best stories remind us to put down the book.

BY SARA CAMP MILAM

THIS MAY WILL MARK TEN YEARS SINCE I moved to Oxford and joined the Southern Foodways Alliance as a full-time staff member. That's forty issues of this publication and 161 episodes of *Gravy* podcast. A book about cocktails. A marriage. Two children. Twenty coworkers. A home. A grown-up life, the contours of which I dreamed of a decade ago but the interior (and physical, for that matter) evolution of which I couldn't have fathomed.

Melissa Hall's then-middle-school–aged sons, who helped carry my duffle bags and books into my first Oxford sublet, are now kind, thoughtful, hard-working, and very funny grown men. I admire them, and I admire the woman who raised them, the woman who is now my boss and the codirector of this organization.

Back then, before I had children of my own, I called *Gravy* my baby. Sometimes I still do. But my relationship to this endeavor has changed—in a healthy way, I have to believe—as two very real, very human babies nudge me to continually reassess what I'm working on, and how much, and why, and for whom.

Guilt is a largely useless and self-indulgent emotion, yet it's one that I feel often and acutely, especially since becoming a mother. When I'm at work, I miss my children. When I'm with them during business hours, as I'm lucky enough to be with some regularity, I feel guilty for not working. "Mom guilt" is a cliché for a reason, a beast with so many heads. (Screens. French fries. Piles of laundry. Neglected professional obligations.)

Early in the pandemic, my brain decided to fixate on a new breed of guilt that has dogged me intermittently for the past two years: the guilt of not being a frontline care worker, specifically a nurse. Never mind that I am terrified of needles, blood, and hospitals; never mind that my mind struggles to grasp most concepts of hard science; never mind that I already have a fulfilling job, one which helps support and sustain my family. If I'm going to spend time away from my children to work, my logic went, shouldn't I be engaged in a vocation that helps others more directly, more immediately, and—here comes that loaded 2020 buzzword—more essentially?

I'm still trying to untangle the extent to which this guilt is fed by a warped sense of how much one person can or should do. I'm still working on balancing the attention and worry I direct inward, toward myself and my family, with the

attention and worry I direct outward, toward a world that sometimes feels heartbreakingly, paralyzingly filled with suffering. And from a comfortable orange chair in an office located in a literal tower (albeit one of board-and-batten, not ivory), I often feel small, and abstract, and sometimes even useless.

While I am mostly an editor, and only occasionally a writer, I have undoubtedly made it my vocation to traffic in narratives. Most of these narratives relate to food, a subject that I occasionally tire of, only to find myself surprised and delighted by something new just when I seem to need it. Most of them are set in the South—my home—a place I find real and beautiful and and infuriating and full of possibility. If pressed to distill a decade's worth of stories into a few words, I would say that the best of them are either about places worth protecting, whether built or natural; or about unfamous people doing work that matters very much. These places and people frequently overlap.

Ten years ago, I might have said that stories can save us. I no longer believe that, but I offer an alternative that's still on the side of hope. The last two years have led me to believe that what will save us (in a purely secular sense) on both an individual and societal level is connection. By that I mean connection with the natural world and with other people. Connection that is physical, not modified or mitigated or algorithmically filtered. We tend to say that stories can take us places we've never been and introduce us to people we'll never meet. They can't—not really. But they *can* remind us how vital these experiences and connections are. I believe they can stoke curiosity and raise questions we carry over into real life. I believe they can alter our perspectives, if we're willing to bring that open-mindedness to the messy, difficult reality of everyday life, where beginnings, middles, and ends are never as orderly as paragraphs or as clearly delineated as section breaks.

I don't know where I'll be or what I'll be doing in another ten years. My father worked at the same law firm for nearly forty years before retiring. Many of my peers switch jobs every two to five. I imagine I'll still fret over things beyond my control. I imagine I'll still have pangs of unhelpful guilt. I'm pretty sure I'll have my nose (or ears) in a book every chance I get. But with any luck, I'll remember more often to put it down and live. 🏆

Hanna Raskin is editor and publisher of *The Food Section*, a Substack newsletter covering food and drink in the American South. In 2017, the James Beard Foundation awarded her its first Local Impact Journalism prize. A past president of the Association of Food Journalists, Raskin served as food editor of *The Post and Courier* in Charleston, South Carolina, from 2013 to 2021, a job which led to her pawing through trash cans for evidentiary pizza boxes and swimming in a tub of grits. She joins *Gravy* as a columnist (The Smoking Section) beginning in this issue.

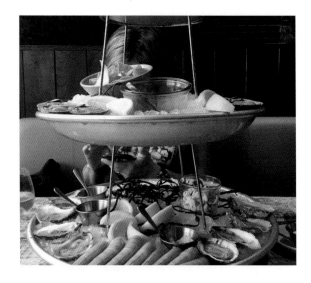

Natalie Nelson is an illustrator, picture book maker, and collage artist. She works in a mixed-media hybrid of cut paper, collage, and digital art, and sees this layered approach as a visual metaphor for the changing South. She has produced editorial illustrations for *The New York Times*, *The Washington Post*, *Time* magazine, and more. Her latest picture book is titled *Dog's First Baby*, and the companion, *Cat's First Baby*, will be released this spring from Quirk Books. She lives in Atlanta with her husband and young son.

Lucien Darjeun Meadows is a writer of English, German, and Cherokee descent born and raised in the Appalachian Mountains. He has received fellowships and awards from the Academy of American Poets, AWP Intro Journals Project, and National Association for Interpretation. When not writing, cloudwatching, or volunteering as a ranger assistant in Colorado, Meadows can be found veganizing family recipes (a recent success: brown sugar "buttermilk" pie). His debut poetry collection, *In the Hands of the River*, is forthcoming from Hub City Press in September 2022.

TOP TO BOTTOM: Allisyn K. Morgan; Natalie Nelson; Lucien Darjeun Meadows

APRIL 9 – SEPTEMBER 11, 2022

A MOVEMENT IN EVERY DIRECTION
LEGACIES OF THE GREAT MIGRATION

AT THE MISSISSIPPI MUSEUM OF ART

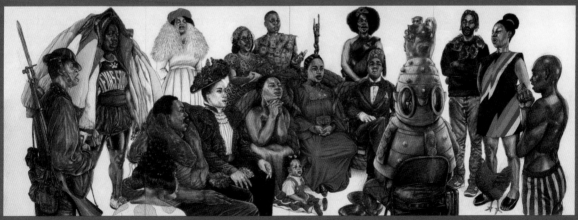

Robert Pruitt (b. 1975), *A Song for Travelers* (detail), 2022. charcoal, conté, and pastel on paper, mounted onto four aluminum panels. Courtesy of the artist. Image courtesy of Adam Reich.

Be the first to see breathtaking artwork on the lasting impacts of the Great Migration created for this exhibition by 12 acclaimed contemporary artists!

A Movement in Every Direction: Legacies of the Great Migration is co-organized by MMA and BMA with support provided by the Ford Foundation, Henry Luce Foundation, Andy Warhol Foundation for the Visual Arts, Bloomberg Philanthropies, and the National Endowment for the Arts. Its presentation in Jackson, Mississippi, is sponsored by the Robert M. Hearin Support Foundation, W.K. Kellogg Foundation, Lucy and John Shackelford Fund of the Community Foundation for Mississippi, The Selby and Richard McRae Foundation, Trustmark National Bank, Mississippi Arts Commission, Mississippi Humanities Council, Visit Mississippi, Visit Jackson, the Ramey Agency, and H. F. McCarty, Jr. Family Foundation.

MISSISSIPPI MUSEUM OF ART

BMA
BALTIMORE MUSEUM OF ART

MSMUSEUMART.ORG

Simone Delerme teaches anthropology and Southern Studies at the University of Mississippi. Delerme grew up in a predominately Puerto Rican enclave in New York City and developed an interest in Latin American and Caribbean studies while studying abroad in Cuba and Mexico. Her first book, *Latino Orlando: Suburban Transformation and Racial Conflict* (University Press of Florida, 2020), focuses on Puerto Rican migration to central Florda and the social-class distinctions and racialization processes that create divergent experiences in Southern communities.

Linda Golden is a freelance writer who reads, bikes, bakes, and works in higher education in Washington, DC. A Swiss-Texan who grew up in Dallas and Houston, she has continued to move farther and farther north. In winter, she dreams of gumbo and the Gulf of Mexico. Her work has been published in *Atlas Obscura*. Her writing projects are driven by a desire to learn about strangers' stories and choices and to share those stories with others—such as a Filipino American restaurant in DC with a generous chef and owner.

Susana Raab is a Peruvian-born photographer based in Washington, DC. She began her career as a photojournalist in Washington covering politics and now pursues a wide variety of subjects, particularly the cultural factors that go into place-making in the South. *Consumed,* an exploration of fast food in America, defined the quirky and serious topics she investigates. Her recent work has focused on the DC neighborhoods east of the Anacostia River, and in Peru, where she finished an upcoming body of work, *Precious Stranger*.

CENTER FOR
THE STUDY OF
SOUTHERN CULTURE

UNIVERSITY OF MISSISSIPPI

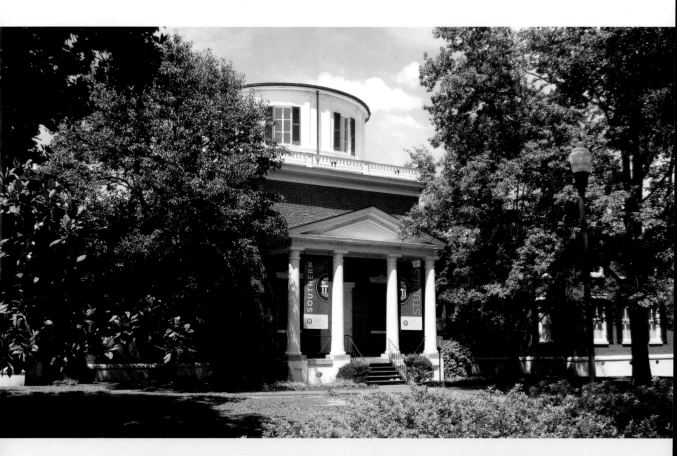

The Center for the Study of Southern Culture at the University of Mississippi, located in Barnard Observatory, is the home of the Southern Foodways Alliance.

COME STUDY WITH US

Be a part of innovative education and research on the American South with our B.A. and M.A. degrees in Southern Studies, and M.F.A. degree in Documentary Expression.

Visit **southernstudies.olemiss.edu**

Southern Foodways Alliance
Most Visited Places

SFAMVP

LAWRENCE WEEKS' Louisville

LAWRENCE WEEKS GREW UP IN LOUISVILLE, KENTUCKY, AND COOKED there in his early twenties, but he left when the food scene began to feel stagnant to him. After working for Todd Richards in Atlanta and Ouita Michel at Lexington's Honeywood restaurant, he returned home as chef of the new North of Bourbon. Now, Louisville's dining scene reflects its diverse population. "I see a boom of artisans and the younger generation of chefs and creators taking off here," Weeks says. "I didn't think I was going to come back, but the homecoming has been great."

North of Bourbon

We're a restaurant and bourbon bar that focuses on the connection between New Orleans and Louisville. We want to educate guests on the subcultures that aren't always highlighted—Italian, Vietnamese. I love it because I've gotten to learn about those subcultures myself. My great-great-grandfather was Chinese, and I found out that the Chinese were down South helping build the transcontinental railroads and mixing in the Black community. I get to show people the history of New Orleans beyond étouffée, gumbo, and po-boys.

Red Hog

Red Hog is an artisanal butcher shop using local animals to do whole-animal cuts and subprimals. They also have a restaurant. I'll get a cocktail and sit at the bar, and after I have dinner or snacks, I'll take home a steak or something that I can cook the next day. They have a sardine toast that's really good, and their menu changes pretty often.

Frazier History Museum

My favorite exhibit is the bourbon exhibit, which highlights Al Capone and the bootleggers, and the history of distilling in America. There are artifacts and old-school bottles from pre- and post-Prohibition. When bourbon used to be outlawed, companies would circumvent the laws by saying it was medicine—a pint or a bottle a day was a prescription. It's downtown on Whiskey Row. The buildings down there were barrel houses, and they would age bourbon in those basements.

Jasmine Chinese Cuisine

My family used to go there when I was a kid, and we would always eat from the Americanized menu. When I was sixteen or seventeen, I went in and they handed me an authentic [Chinese] menu. The lady apologized, but I was like, 'Hold on, now—y'all have been holding out for ten years!' That was the first time I really had Szechuan food, and I fell in love with it immediately. I like the garlic green beans, Chongqing chicken, and the spicy eggplant. Then I'll get the dan dan noodles and some dumplings.

Illustrations by Bridgette Blanton / Tiny Pencil Studio

Most Visited Places is an ongoing digital and print series underwritten by The Mountain Valley Spring Water.

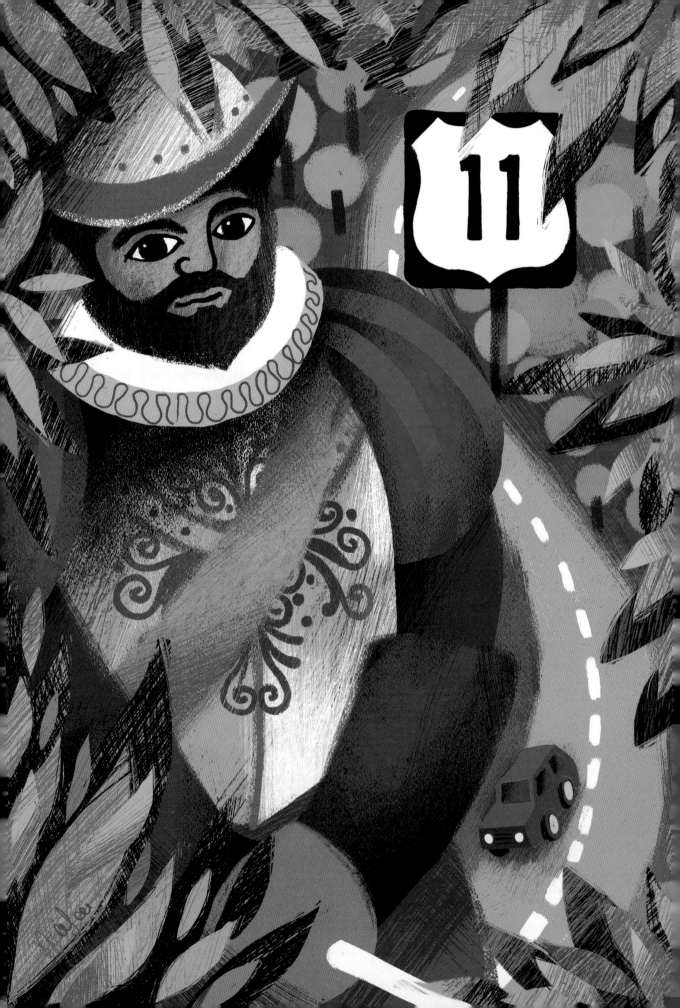

CANCEL THIS CONQUISTADOR

The South still commemorates Hernando de Soto. Instead, it should hold up another Spaniard.

BY GUSTAVO ARELLANO

IT HAPPENED ON AN ALABAMA SUMMER morning. About a decade ago, off US Route 11. Somewhere between Gadsden and Mentone, during my first time in the state.

My wife and I were on the lookout for antiques. We enjoyed getting lost in northeast Alabama's charming towns, all seemingly carved into hills. Our drives on steep, winding roads frequently slowed to crawls as we tried to absorb every mile of giant green trees, which filtered the sun like a kaleidoscope.

Our native Southern California was the farthest thing from our minds for hours—until we came across a jarring reminder of home.

A giant billboard featured a cartoon Spanish conquistador.

He was smiling. Bushy mustache and goatee. Wearing armor, a helmet, and striped pantaloons, the stereotypical uniform of medieval Spaniards in the American imagination. I can't remember what he was trying to sell us, but Google Maps told me we were near DeSoto State Park. As in Hernando de Soto, the first European to travel through what's now the American South.

American historians and civic leaders long hailed the Spaniards who marched through the Americas from the fifteenth through the eighteenth centuries as brave men who navigated a strange new land in the name of civilization and Christ. Their names continue to adorn schools, streets, cities, parks, businesses, and beaches across the United States, especially in the states where they set foot.

Out in California, the most commemorated conquistadors are Juan Rodríguez Cabrillo, Juan Bautista de Anza, Gaspar de Portolá, and Saint Junípero Serra, the Franciscan missionary who arrived in their wake to establish missions throughout the state.

In the South, it's almost exclusively de Soto.

After I realized how close we were to his eponymous state park, the billboard made more sense. But I was still flummoxed. When I got to our hotel room, I Googled "Spanish conquistadors South," because I just couldn't understand why the region would continue to celebrate a Spanish past that rarely, if ever, figures into its modern-day collective identity.

I soon discovered that parts of the South remember de Soto with a public veneration that approaches mania.

A native of the Extremadura region of Spain, de Soto was cruel even by the standards of his era. He helped to conquer Central America and became a slave trader there. His cunning earned him an assignment in Peru, where he had a hand in taking down the Incan Empire. He returned to Spain a wealthy man, but was sent back to the so-called New World and asked to conquer North America for the Spanish crown. De Soto and his troops landed at what's now Tampa Bay on the Gulf Coast of present-day Florida in 1539.

Archaeologists and historians dispute the party's exact path from there, but we know that de Soto died in 1542 and was buried in the Mississippi River. And we know that, for centuries afterwards, his exploits in the South weren't forgotten. In fact, they were commemorated.

Every Southern state except Virginia claims a part of de Soto, whether by place names or trail markers. Cities and counties assumed de Soto's first or last name starting in the 1800s. Historical plaques bloomed in 1939 and 1940 along his putative route in the wake of the United States De Soto Expedition Commission, which sought to celebrate "the first and most imposing expedition ever made by Europeans into the wilds of North America" on occasion of its 400th anniversary.

Celebrations continue to this day. There's the De Soto Heritage Festival in Bradenton, Florida, a city near where the conquistador originally landed, complete with a parade and a grand ball where men dress like the caricature I saw on that billboard. At Desoto Caverns near Birmingham, the mascot for years went by Happy Hernando, a costumed employee who wandered around the park and took pictures with children as if he were Mickey Mouse at Disneyland.

Even we in California never went that far.

There are still monuments dedicated to our conquistadors, and their names are still prominent parts of the California landscape. But the days of hailing them as heroes are long gone. Protestors tore down statutes of Serra in public spaces across the Golden State in 2020, while cities and churches preemptively removed them. Everyone expects the State Legislature to eventually yank a statue of the saint that has stood at the United States Capitol's National Statuary Hall since 1931.

Following recent changes to the state's curriculum, California schools now teach students that those Spaniards from centuries ago, long respected by previous generations as heroes, were nothing more than men who massacred Indigenous people, took their lands, enslaved the survivors, and ostracized their culture.

The de Soto billboard encounter has stayed with me all this time, but I especially thought about it over the last two years, as the United States has experienced a reckoning over how we remember our past and whom we choose to venerate with public monuments and namesake buildings.

A reverence for de Soto is unbecoming of the South, especially since his own chroniclers described his expedition as blazing a path that left thousands of Native Americans dead and introduced diseases that would kill off even more. Why bother with a guy like that when living, breathing Latinos are imparting a far more substantial cultural imprint than the Spanish interlopers from so long ago?

Besides, there's another Spaniard from the Age of Exploration who's a far better candidate for the South to honor.

Álvar Núñez Cabeza de Vaca was a member of the 1528 Pánfilo de Narváez expedition, which sought to settle what is now Florida on behalf of the Spanish crown. The 300-plus group made landfall that spring, only to find disaster wherever they went as they sailed along the Gulf Coast and up to the mouth of the Mississippi River. Four years later, Cabeza de Vaca was just one of four survivors of the original brigade—and he was at the mercy of various Gulf tribes that traded him like tender.

When Cabeza de Vaca encountered other Spaniards eight years later in what is now northern Mexico, the Native Americans who accompanied him refused to believe he was from the same

> When I saw the de Soto billboard in Alabama, I couldn't understand why the region would continue to celebrate a Spanish past that rarely, if ever, figures into its modern-day collective identity.

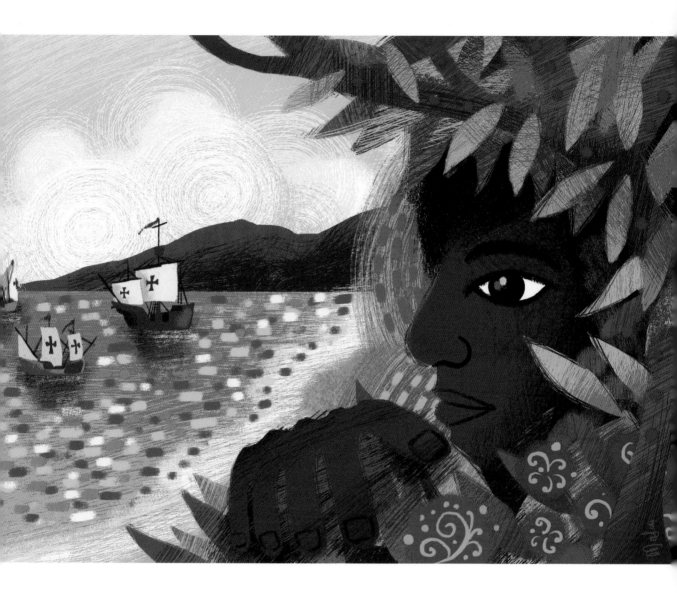

country as the conquistadors. By then, Cabeza de Vaca was no longer a slave. He freely traveled among tribes as a healer. He took the time to learn the languages, customs, and ways of life of the people he encountered. He had become a part of their society, rather than trying to subjugate them like his fellow Spaniards.

"We healed the sick, they killed the sound," he wrote in memoirs that still make for a gripping read centuries later. "We came naked and barefoot, they clothed, horsed, and lanced; we coveted nothing but gave whatever we were given, while they robbed whomever they found and bestowed nothing on anyone."

Of that encounter in present-day Mexico, Cabeza de Vaca said that he and the Natives who were with him came from the sunrise, while the Spaniards came from the sunset. While it's no doubt a simplification of a complex reality, it's a compelling metaphor: Native folks are cast as people who greet possibility and light, while the Spaniards brought darkness to the lands they captured.

But Cabeza de Vaca's insight also speaks to the moment we live in today. A new dawn is rising across the country, offering a different way to think about our history. We should hold up the Cabeza de Vacas as people who, even centuries ago, showed us a different way of how to live.

Meanwhile, may the de Sotos of yore go with the dusk. 🍸

Gustavo Arellano is a Gravy *columnist and host of the podcast* The Times: Daily News from the L.A. Times.

FLAME AND FORTUNE

Barbecue and celebrity have always been on good terms.

BY HANNA RASKIN

IF TALKING ABOUT THE WEATHER IS THE lowest rung of small talk, sharing pictures of traffic has got to be the rock bottom of text conversations.

Yet on September 5, 2020, I received image after image of idling cars, sent by fellow Charleston residents. They guessed correctly that I'd share their fascination with the blocks-long line leading up to the drive-through window at Rodney Scott's Whole Hog BBQ on upper King Street.

"Wow," one restaurateur messaged. "The power of Netflix."

Scott, whose family started selling barbecue in rural South Carolina in 1972, launched his eponymous venture with restaurateur Nick Pihakis in 2017. After Netflix featured Scott in its hugely popular *Chef's Table* series, thousands of eaters who navigate by the stars flocked to the Charleston and Birmingham locations of Scott's restaurant. Over the 2020 Labor Day weekend, the Charleston store broke its sales record three days in a row.

"It got real crazy," Scott told me once the hour-long waits had subsided.

Barbecue has been part of the Southern culinary landscape for centuries. In the last decade, though, as the tradition has migrated from the countryside to big cities—and has been documented relentlessly by both the professional media and unpaid fans based there—barbecue has become a singular catalyst. In the months leading up SFA's 2022 Fall Symposium on barbecue, I hope to use this column to explore what barbecue has yielded beyond gustatory pleasure and cardiac pain.

First up: Fame.

BARBECUE AND CELEBRITY have always been on good terms. In his 2021 book, *Black Smoke: African Americans and the United States of Barbecue*, Adrian Miller profiled several "barbecue kings" who in the late 1800s and early 1900s acquired regional reputations for smoked meat excellence. And he rightly surmises that some of them would have reached even greater heights if not for racism and segregation.

It makes sense that barbecue would produce more big names than other cooking styles. Beyond the mythic dimensions of taming fire, pitmasters are alluringly off-limits in ways that your neighborhood cheesemonger isn't: After all, they do their most important work in firetraps under cover of darkness. And by virtue of their transforming a single beast into meals for scores of omnivores, they're almost assuredly known by masses of strangers.

Illustrations by Emily Wallace

Bar·B·Q

PIT BBQ

VOTED #1
BARBECUE

Ribs

BBQ

CUE

WORLD FAMOUS

BARBECUE

HICKORY-SMOKED
BARBECUE

CRAZY FAMOUS

BARBECUE

BRISKET

While I grew up in a town where Crockpots were more common than barbecue rigs, even Ann Arbor, Michigan had a well-known barbecue maker: Jesse Campbell, a native of Starkville, Mississippi. In 1974, he opened the restaurant that would eventually be called Mr. Rib.

In the early 1990s, after Desmond Howard came off the field at Michigan Stadium, students would queue up at Campbell's concession for a Soul on a Roll, a pulled-pork sandwich topped with slaw and a sweet, tomato-based sauce.

Still, the *Ann Arbor News* in 1995 reported that Campbell "had troubles with the tax man, a local landlord and a liquor store that wouldn't stay solvent. He's had trouble raising capital and, most recently, trouble with pneumonia."

That's a far distance from true celebrity and the safeguards that come with it. But in my fifteen years as a food journalist and restaurant critic, I've watched fame emerge as an essential component of the barbecue scene.

MY FIRST PAID food writing job was at the *Mountain Xpress* in Asheville, North Carolina, a city where barbecue didn't qualify as a major food group. Once, at the National Country Ham Association's annual conference, I told an attendee that I was forever explaining to visitors interested in barbecue that they'd come to the wrong end of the state.

He shook his head. "Wrong end of the pig," he said.

Either way, Asheville's interest in barbecue picked up with the opening of 12 Bones Smokehouse in 2005. Much of the restaurant's name recognition was fueled by reflected glory: In 2008, then-presidential candidate Barack Obama swung by for an order of blueberry chipotle ribs. (Those kooky ribs could well be the poster item for in-town barbecue restaurants, where menus aren't ruled by misplaced nostalgia for outdated flavors or inferior ingredients.)

It would be another seven years before Elliott Moss—whom I knew as the chef making mocha stout pimento cheese and brie mashed potatoes at a dive bar called The Admiral—would launch his eastern Carolina–indebted Buxton Hall Barbecue.

By then, I'd left town for a job at the *Dallas Observer*. I moved to Texas in 2010 knowing barbecue was a big deal there, but it turned out the genre in those days was mostly exempt from the flashiness that's a state signature. When I arrived, the general attitude toward barbecue and the people who made it was so low-key that a Super Bowl XLV party hosted by Man Up Texas BBQ drew hundreds fewer people than anticipated.

Granted, there was a nasty ice storm in February 2011, but it's hard to imagine folks not turning out today for a free taste of what Franklin Barbecue and Snow's BBQ were serving.

"People were walking out with briskets," my friend Daniel Vaughn says of the leftover situation.

WHEN I MET DANIEL, now barbecue editor at *Texas Monthly*, he was an architect who wrote a blog called *Full Custom Gospel BBQ*.

Twitter existed in 2008, but all of its users combined sent about 300,000 tweets a day. (By comparison, that many tweets now go out every 50 seconds.) Instagram hadn't been invented. So, when Daniel took issue with a Dallas food blogger's contention that the barbecue around Dallas was only "dog food or sandwich worthy," he decided to start a blog of his own.

"I thought all the barbecue I was eating around here was fine and dandy," Daniel recalls. "The dry brisket at Peggy Sue's—which just got bulldozed yesterday—I thought that stuff was primo."

Then Daniel went down to central Texas, where the beef ravished his palate and upended his mind. He took his new appreciation back to Dallas, determined to turn up local gems by screening every barbecue joint in the DFW area.

Before long, Daniel had enough material to write a 2010 story for *D Magazine*, featuring a list of his top sixteen barbecue places. Half of them showed up on a list published soon thereafter by *Dallas Morning News* restaurant critic Leslie Brenner.

Concerned about the overlap, Daniel emailed Brenner. He received a snippy response, which he forwarded to me. Since an alt-weekly's highest purpose is to call out the mainstream press, I wrote about the incident in the *Dallas Observer*.

As Daniel puts it, "It blew up from there. Anthony Bourdain reveled in the fact that [Brenner] looked bad," because she'd panned one of Bourdain's books when she worked at the *Los Angeles Times*.

In 2012, Bourdain chose Vaughn as an author for his Ecco imprint and featured him on *No Reservations*.

In other words, Daniel got famous.

DANIEL FIRST GOT an inkling of his change in stature when he read an online comment from someone who said they weren't going to try a new barbecue restaurant until Daniel ruled on it. He knew for sure things had changed when a barbecue owner asked his advice.

Now, he says, "The thing that comes specifically with being well known is all the pitmasters want to act like your friend. You always have to question, 'Why are they inviting you out for oysters when you're in town?'"

"Our [Top 50] list [at *Texas Monthly*] comes around every four years, so you get to learn what their motivations were," he continues. "It's oftentimes painful."

But having influence also gives Daniel the chance to prop up barbecue makers who otherwise might be overlooked. Plus, he gets invited to parties that are much better than the Super Bowl debacle we attended at the House of Blues.

In 2013, Daniel flew to Seattle to meet with representatives of Amazon. By then, I had transferred to the *Seattle Weekly*, so I was there when he filmed an *ABC News* segment at Jack Timmons' house.

A Microsoft employee and 2012 alumnus of Barbecue Summer Camp at Texas A&M University, Timmons had started a pop-up brisket series using a smoker in his backyard. Daniel had that smoker in mind when he asked Timmons to join him for a follow-up residency arranged by Seattle celebrity chef Tom Douglas.

At the event, "Sir Mix-a-Lot [ate a beef rib] and started chasing me on Twitter," says Timmons, who's remained friends with the Seattle rapper, née Anthony Ray. The crowd's response, a clear indicator that neither the South nor Texas is big enough to contain the phenomenon of barbecue celebrity, persuaded him to upgrade from an illegal operation to a proper restaurant.

Timmons opened Jack's BBQ in 2014, one year after I moved to Charleston.

Since then, he's opened three additional locations and a Tex-Mex restaurant. When I Googled Timmons to make sure the email address I had for him was current, the first result referred to "Texas native Jack Timmons of Jack's BBQ fame."

"It's so silly," Timmons says of the public adoration, which he admits has been stoked by entertaining influencers and posing for goofy Instagram pictures. "When I grew up, Julia Child and The Galloping Gourmet were on TV, and if people asked me where I ate barbecue, they didn't have names: It was just 'the place on Garland Road.'"

By contrast, barbecue has brightened the lights around Timmons' name so intensely that it now means more to potential patrons than his ribs or brisket. He's recently opened a ghost kitchen called Jack's Chicken Shack. His Tex-Mex joint is Jackalope. He hasn't ruled out a Jack's Roadhouse.

Because when "they see 'Jack's,'" Timmons says, Seattle diners line up to place their orders. 🍸

Hanna Raskin is Gravy's *new columnist. Her newsletter,* The Food Section, *is published on Substack.*

EVEN AFTER, THOSE ROSES BLOOM

BY LUCIEN DARJEUN MEADOWS

Each morning, I open Elisi's curtains, unshutter windows,
Give breeze to her house still heavy with death—
Six months ago my uncle, nine months ago my grandfather. Each morning,
My aunt crosses the field between our houses, barefoot and bearing wildflowers
From the hollow by the woods where her husband's Cabrio still sits,
Untouched, submerged in violets.
Sweet tea on the back porch, and we watch Elisi's Bourbon roses
Trellis up the laststanding section of a horse fence
Dismantled two decades ago, when the horses were sold. Each year, these buds
Open a bright coral, constant
Since her mother's first planting—the spring of her marriage,
Year of Elisi's birth, outside a bungalow by a wide river—
But this summer, her roses are stained
A dark maroon.
First blooming since last summer ended a union
Held since she was sixteen, blush of grief into a disappearing
Body: body once of love,
Body now dissolving into light, body of rose, of Susquehanna
And Allegheny, body who always woke before dawn,
Body now in the back room until noon, dreaming—body longing
To pour time's molasses backward, unpack bags
Of his clothes, back past hospital bed and morphine, back to bringing out root beer
And gingersnaps to this porch, where she knows
He will come, driving the Deere
Across the pasture, past his gardens of tomato, spinach, cucumber,
To hold her on this porch
Where we sit, stirring the hours with her mother's long spoons
As each rose opens a strange darkness, then tips
Their duskheavy head toward the earth.

Lucien Darjeun Meadows is an English, German, and Cherokee writer born and raised in the Appalachian Mountains. His debut poetry collection, In the Hands of the River, *is forthcoming from Hub City Press in September 2022.*

Illustration by Cali Sales

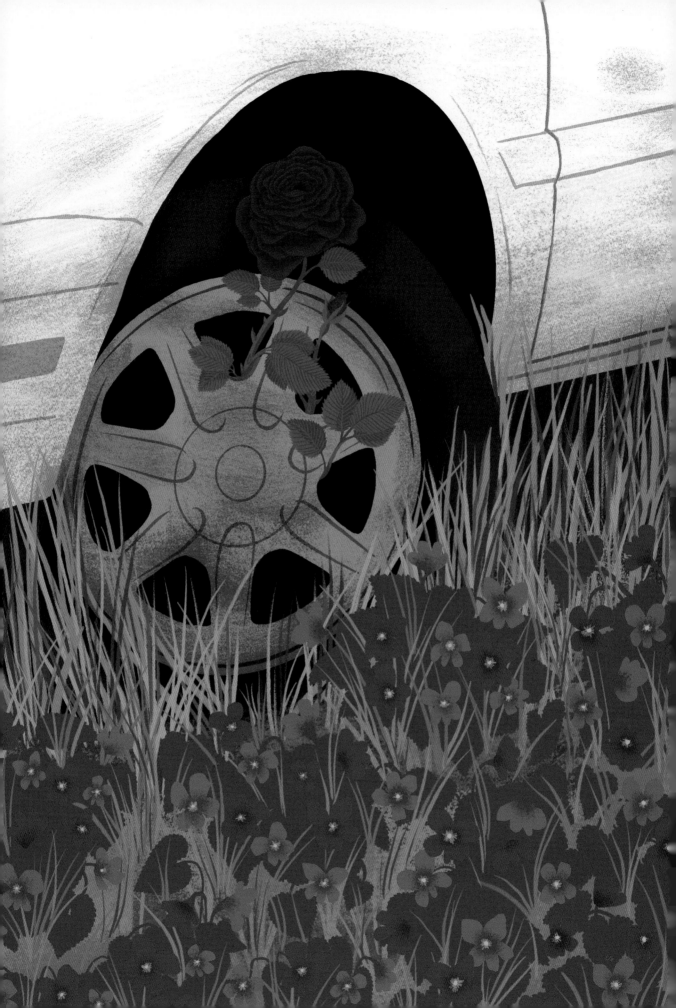

SERVICE NOT INCLUDED?

A tacit understanding between server and guest has been altered.

BY JOHN KESSLER

TWO NIGHTS BEFORE THANKSGIVING, I brought a boisterous seven-top into HaiSous, a modern Vietnamese restaurant in Chicago run by a noted chef named Thai Dang. The waiter managed to quiet my loud clan enough to get our drink orders and brought them in good time. After a couple of prods encouraging us to order food, he took command of the conversation, sussing out the family vibe better than most of the boyfriends my kids have brought home. Better yet, he had a plan. He heard every corner of the table mention whole fish, so we needed two of those. Also: both noodle dishes, all the veggies, and whichever small plates people wanted to call out. The non–cocktail drinkers had mostly chosen the same glass of wine for the first round, so, a bottle for the second?

The meal was it: the quality restaurant time we'd been needing for the past two years. It was like a great night from the Beforetimes, when my family, friends, and readers all felt so passionately about going out to eat. What was the best? The chili-tamarind crab noodles? The grilled eggplant? Honestly, the food was all great. And the service was flat-out amazing.

Such experiences for me are now uncommon.

In part, it's because expensive restaurant fare has become less necessary since quarantine made me a better mixer of craft cocktails and shucker of oysters. But I wonder if the main difference I'm noticing is in service. It's like a tacit understanding between server and guest has been altered.

"It was so invisible and baked into the experience before," John deBary, cofounder of the Restaurant Workers' Community Foundation, told me, "The reason to go to a restaurant isn't consuming nutrition, but to be taken care of."

Like most restaurant critics, I never gave this basic truth enough credence. I'd prattle on in detail about food but would expect service to be on point. Sometimes it was because I was recognized and didn't want anyone to think I was the kind of "influencer" who demanded special treatment. Sometimes it was because smooth service (like good writing) looks easy and effortless, when really it's an exercise in juggling skills, knowledge, and calculations.

Yet I did write about service more than most critics. Often, I'd "go to the bathroom" so I could stand somewhere out of sight lines and watch. First I'd try to figure out the big picture. Was there a floor manager? Were there captains and

Illustrations by Molly Brooks

assistant waiters, or waiters and bussers, or just waiters? Did servers have to run their own plates from the kitchen, or were there food runners?

Then I'd look for faults. Were wine and water glasses empty? Did servers stop by tables holding other people's dirty plates en route to the kitchen? Did they deliver food to the wrong tables? Was the timing off on busy nights, leaving some guests grumpy and foodless while others had their entrees dropped right after appetizers?

Finally, the intangibles: Did the room have good energy? Did the waiters work as a team? Did they read the customers well and adjust their banter and interactions accordingly? Did they make their guests feel taken care of?

While it'll probably piss off everyone in the industry who reads this, I just don't feel as well taken care of these days. A few examples from the past year: I arrived at a fast-casual spot before closing time and found the staff breaking down. Not even an "I'm sorry." The waiter at a mid-level restaurant took forever to greet us and then so thoroughly misidentified every dish it was clear he was spitballing. At a very expensive tasting-menu spot, a server had to consult his notes to describe the artistry behind a torturous-looking, slate-and-metal serving piece but forgot to tell me about the blob of mystery food on it. I think it was fish.

At many restaurants, service has become mechanical. You pull up a QR code–enabled menu on your device, the waiter arrives masked and distanced, and you order.

I know that eating out—having someone cook your food, bring that food to you, and then do your dishes—is a privilege. One that I've perhaps learned to take for granted during the past ten or fifteen years when I, and a hell of a lot of other Americans, had begun dining out as often as we cooked at home. (One Nielsen report found that the amount of money Americans spent in restaurants nearly doubled between 2003 and 2018.) There was never a shortage of small, new, chef-driven places to check out.

The early months after quarantine were marked by an upheaval in dining, and chefs were called out for creating abusive work environments—a new chapter of racial, gender, and class-based reckonings that further unsettled the country in 2020. Front-of-house restaurant workers figure

At a very expensive tasting-menu spot, a server had to consult his notes to describe the artistry behind a torturous-looking, slate-and-metal serving piece but forgot to tell me about the blob of mystery food on it. I think it was fish.

prominently in what psychologist Anthony Klotz termed "the Great Resignation," the decision by 47.4 million Americans to call it quits on unfulfilling jobs in 2021. As Atlanta restaurant server Molly Belviso puts it, "Everyone who could possibly get out got out. The only people who are left now are the waiters making $100,000 a year or the people like me with a side hustle." (She sells gifts and crafts when not waiting tables.)

If she's right, what next?

Belviso explained that those who've decided to stay in the service sector and those who've decided to join it, lured by lucrative signing bonuses and benefits, aren't bound by the same unspoken rules of good service. "We've gotten rid of that idiot 'the customer is always right' model the industry did to itself," she says.

That dictum, coined by department store owner Harry Gordon Selfridge in the early 1900s, became a foundational principle for what restaurateur Danny Meyer would term "enlightened hospitality" a century later in his bestselling book, *Setting the Table: The Transforming Power of Hospitality in Business*. In brief, Meyer argued that good hospitality elicits an emotional response from guests. "The service is the technical delivery of a product. Hospitality is how the delivery of that product makes its recipient feel," he writes. Published in 2006, the book had a profound effect on both young people entering the industry and those training them.

For deBary, just embarking on his career as a bartender with the Momofuku Group, it was like a bible. But in an op-ed published last year in *Food & Wine*, he argued it was time to rethink Meyer's philosophy of hiring workers with "emotional intelligence" who thrive on caring for others. When I spoke to deBary, he explained that it created a norm where servers had to "capitulate to every desire of the guests. Maybe it was true to an extent, but it got kind of weaponized and went from this rarefied luxury to something expected." (Or, in Belviso's words, "Fine dining had become about how much abuse you can take with grace.")

By the mid-2010s, the tipping system that had long provided the wages and rewards for good service was coming into question. Until then, most restaurants took a "tip credit" that allowed them to pay front-of-house workers only a little more than $2 per hour with the assumption that most of their wages came in tips. Sure, servers could leave on good nights with a wad of cash, but the problems inherent in the system were rife. Back-of-house workers felt like poorly paid, second-class citizens; women and people of color routinely earned less; and restaurants that pooled tips often engaged in wage theft. When the New York restaurant Sushi Yasuda did away with tipping in 2013, it was big enough news to make *The New York Times*. By 2015, Danny Meyer implemented a no-tipping policy in all his restaurants, raising prices accordingly to recapture the lost income. Many others followed suit. The reservation platform Tock permitted clients to build a 20 percent tip into the prepaid price of dinner.

It was a confusing time. Customers hated no-tipping policies because they liked to reserve the right to reward and punish servers. (As someone who drinks a lot of water during a salty restaurant meal, I can remember feeling peevish when my glass sat empty in the face of an autogratuity.) Waiters hated it because their best overtippers were discouraged from dropping that spare C-note. In other words, the service model was already deeply frayed by the time the pandemic dealt its blow.

Also, front-of-house work had become too all-encompassing. No one had a life. Bree Schaffer, who worked in service at the now-shuttered, Michelin three-star restaurant Grace in Chicago, says that fine-dining restaurants "expected you to commit your life to them. There was this 'family mentality' in workplaces. We only hung out with each other, and we had our days off together."

"People are waking up to things they thought were standard but now see as absurd," says deBary. "You could have a fever of 104 but have to come into work. You had to be on all the time."

Staffers who continued working through the lockdowns and the shifting directives and rules regarding contact felt "more empowered to make their boundaries clear," says Schaffer, now general manager at a private club and coworking space. They are more demanding about what shifts and stations they'll work, and what degree of contact they are willing to make with guests.

Those who did return to floor service after the spring 2020 quarantine found a changed world. "When we first opened, it seemed like we were going into battle," recalls Atlanta restaurant manager John McDaniels. At the time he was working at Two Urban Licks, a cavernous place with a young, heavy-drinking crowd. "They didn't care about the mask thing, they didn't care about the social distancing thing," he says. "It was always a battle between you and the guest."

Many servers reported that their tips decreased during that time. "People tipped a lot less when you have your mask on. It all felt kind of robotic. You were there to take their order, drop their plates, and leave," says Elizabeth Campbell, a server at Pricci in Atlanta.

"People were going into shock about things," says Belviso. "They couldn't understand why a restaurant wasn't grateful to drop everything and service them two minutes before close. So many are even more entitled and demanding than they were before the pandemic."

She recalls one night when she was running around taking care of three stations and a guest chided her for taking too long to make contact with his table. "Y'all should hire some more staff," he said. "Absolutely, sir," Belviso responded. "Can I send you an application?"

WHEW. IN THE COURSE of reporting this story, I have shifted from feeling ready to tear into the busted norms to eating at least an amuse-bouche portion of crow. Now I feel like a jerk for complaining above about staffers taking too long to greet me, about restaurants not serving me when I arrive a few minutes before close, and about the impersonal nature of socially distant service. I am so not always right.

But I had one last service professional to speak with: John Doo, the server who made my family dinner at HaiSous so memorable. A ten-year veteran of Chicago fine dining, he has seen many colleagues hang up their aprons.

"A lot of the core members, the lifers, the true professionals, have grown tired of the industry and are looking for a way out," he says. "Every night we're just trying to make sure we're staffed up and we can get through our shifts. But so many staffers are younger and green now."

Doo notes that fewer servers try, or even know how, to upsell. They haven't learned to read their guests. (And, yes, we did get a second bottle of wine.)

Did he have a moment when he thought about changing careers after the lockdown?

"To be honest, I was happy to be back," he said. "No one is forcing you to be here."

Good on you, sir.

In my life, I've performed just about every duty one can in a restaurant. Let me be honest. I am a clumsy person with poor motor skills, and I've dropped trays in the most spectacular fashion. As a busser I was always being yelled at for not moving fast enough. As a waiter, I learned that I did have a few talents. Guests liked me, and I was commended for good wine sales. But I too often got behind in my work and let plates languish under the heat lamps, earning the ire of most chefs I worked with. I did better once I moved to the kitchen, because I could hustle behind the line in a way I couldn't on the floor. My specials were good to great, and I could reliably cook meat to temperature. I was less successful as a head chef because of poor time management and organizational skills, though I was a mentoring boss for young cooks who wanted to learn.

All these jobs honored me. My life was a mess when I worked in restaurants, but I felt the calling. I believed it was a gift to be able to prepare food for people and serve it to them. I still do. When I walk into restaurants, that's what I hope to see. ⚱

John Kessler is a zizzer-zazzer-zuzz, as you can plainly see. He is also the dining critic for Chicago Magazine.

WRITING IN PLACE

FRIDAY, JULY 8 - SUNDAY JULY 10, 2022
WOFFORD COLLEGE | SPARTANBURG, SC

HUB CITY WRITERS PROJECT

- **Classes in fiction, nonfiction, and poetry**
- **Generate new work through prompts and craft talks**
- **Network with writers and faculty**
- **Keynote craft lecture, faculty Q&A, open mic, & more**

The conference is open to 40 adult writers and sells out every year, so register early. This conference is geared toward starting a new piece of work rather than workshopping something you have already written.

Writing in Place is held in the Michael S. Brown Village Center on the north side of campus. Overnight guests are housed in the Village apartment housing.

Basic Registration **$295**
(all meals for the weekend are included)

Registration + Room **$365**
(all meals for the weekend are included)

Add a 20 minute manuscript critique from your instructor for $50

REGISTER TODAY!
visit hubcity.org/conference
call 864.577.9349

2022 Faculty

Keynote Lecturer
TAYLOR BROWN

Nonfiction
SAYANTANI DASGUPTA

Fiction
ASHLEIGH BRYANT PHILLIPS

Poetry
TYREE DAYE

REGISTER: hubcity.org/conference QUESTIONS? 864.577.9349 | kate@hubcity.org

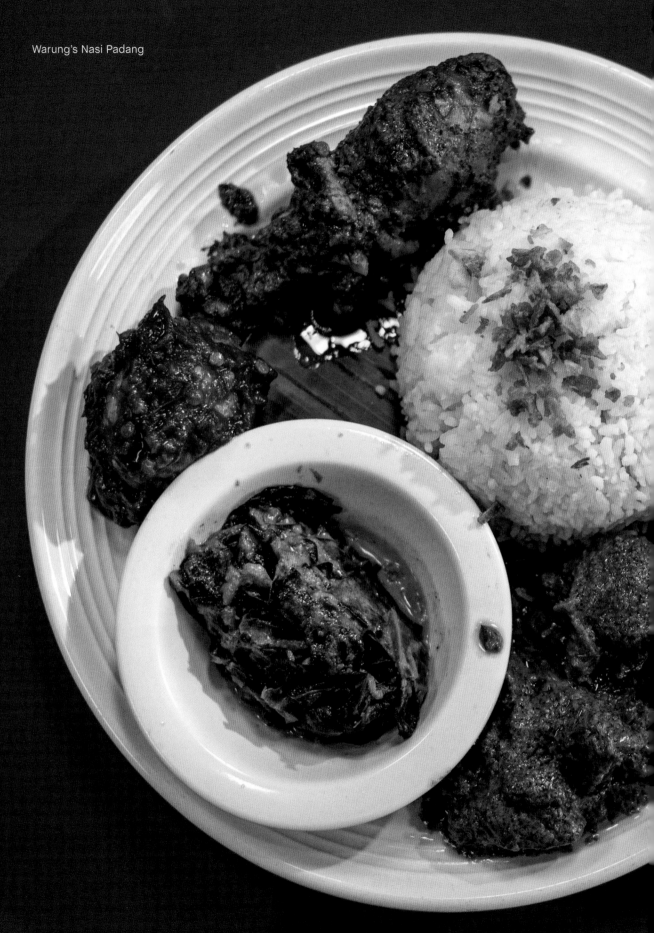

BY KAYLA STEWART

PHOTOS BY BEN GRAY

WARUNG INDONESIAN NOURISHES A DIASPORA

IN THE ATLANTA SUBURB OF
DORAVILLE, INDONESIAN CUISINE
TAKES CENTER STAGE.

IN A SMALL STRIP CENTER LINED WITH RESTAURANTS JUST OFF OF BUFORD HIGHWAY, ONE BUSINESS STANDS OUT.

The fragrant scents of turmeric, ginger, galangal, and chiles entrance the hungry. Inside, golden chairs and red tablecloths, along with Javanese artwork and a large map of Indonesia, clue diners in to the provenance of the menu offerings.

At Warung Indonesian Halal Restaurant, customers are treated to some of the best Indonesian food in the nation. Plates of nasi pecel, a rice dish served with vegetables bathed in a sweet peanut sauce; vegetable fritters called bakwan sayur, hot out of the fryer; and an array of soups, stews, and salads cover the tables as guests eagerly tuck in.

When they opened, they decided to focus on Indonesian food. "We're Indonesian," said co-owner Sri Astuti. "It's gonna be Indonesian-owned, and it's going to be our taste.'"

Astuti and her husband, Deni Mulyana, opened Warung in April 2020, just as the COVID pandemic wreaked havoc across multiple sectors of the economy—including the restaurant industry. Despite the difficulty of opening during such an unpredictable time, the restaurant has gained steady popularity in and around Atlanta.

I lived in Indonesia myself while completing a Fulbright fellowship, and I came to love the country's food. Since returning home to the United States five years ago, I've missed those flavors. I never expected to find them at a suburban Atlanta hole-in-the-wall. I first visited Warung in early 2021. I was cold, tired, and hungry following an eight-hour drive from Little Rock to Atlanta, and the meal was just what I needed. When I later gushed to Astuti about that experience, she took my enthusiasm in stride.

"The expats and people who have been to Indonesia and know Indonesian food, they really appreciate and love the food," she said. "They tell us it makes them feel like they're back in Indonesia, because there's no such fusion in the taste. We've made all the ingredients and spices from scratch."

The Indonesian diaspora in the United States is a relatively small one—a population of about 129,000. There are some 2,000 Indonesian Americans in the Atlanta metropolitan area, making it one of the largest Indonesian communities in the South. Yet fewer than five restaurants in the Atlanta metropolitan area serve Indonesian food. Astuti and Mulyana, who immigrated to the United States in 2001 and 1998, respectively, noticed this absence.

"When we leave the country, we bring Indonesia in our hearts," said Astuti. Even as she sought to build a life in the United States, she says she

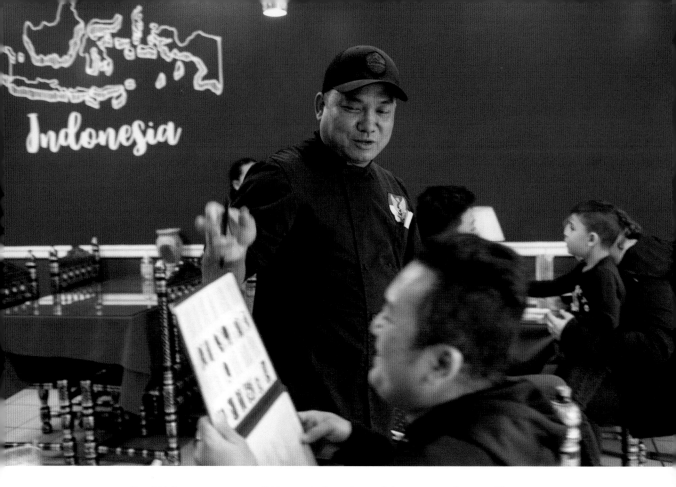

Deni Mulyana, co-owner of Warung Indonesian Halal Restaurant in Doraville, GA, chats with a guest while taking his order in March 2022.

found herself wanting to promote and share her native Indonesia.

Astuti observed other Indonesian-owned restaurants and saw that the most successful ones opted to market themselves as pan-Asian, rather than Indonesian. These restaurateurs rounded out Indonesian menu offerings with dishes from more recognized Asian cuisines: Chinese, Japanese, Thai, or a combination. At first, Astuti tried a similar strategy, running an Indonesian-Asian food stand at local festivals. But ultimately, she was determined to focus on the flavors and dishes of her homeland.

Astuti explained that while Indonesian cuisine is influenced by the food of many other countries, it still has a taste all its own. Even though it was challenging at first, she was committed to communicating her food and her culture.

Rather than give up on the idea of an Indonesian restaurant, Astuti dug into pursuing identity and authenticity even more. She came up with the idea of building a *warung*—the Bahasa Indonesian word for a small, typically family-owned food stand or café—in the United States. As a

Muslim Indonesian, she'd become familiar with the diverse Muslim communities in the United States. She realized that about 75,000 Atlantans identified as Muslim. Coming from a country that's almost 90 percent Muslim, Astuti saw an opportunity: She could market Indonesian food as halal food, attracting Muslim Atlantans of many nationalities.

Astuti decided that Warung was definitely going to be Indonesian, but that she and Mulyana would take a unique approach to promoting it. She researched the demographics of the area and realized how many Muslims lived nearby. And so, as she explained, "Let's introduce us as a Muslim Indonesian [restaurant]...to the Muslim community here."

"Meat is slaughtered out here abundantly in the halal way," said Astuti, referring to ethical and religious butchery practices. So it made sense to market Warung as not just an Indonesian restaurant but a halal-friendly dining destination.

While Indonesian immigrants in the Atlanta area have found a home at the restaurant, Sri says it's non-Indonesian Muslims who make up the

largest portion of her clientele. Guests come in hungry for a meal that's both delicious and that aligns with their religious values.

"Overwhelmingly, we had such a great welcome. A lot of Muslims in this area are not from Indonesia," she said. And, she added, she takes pleasure in introducing non-Indonesian Muslim guests to a new cuisine.

Astuti and Mulyana both grew up in West Java, a province on Indonesia's most populous island. Astuti was born in Bogor, near Jakarta, while Mulyana grew up outside of Bandung, the country's third-largest city. Astuti studied at the National Hotel and Tourism Institute, where she learned how to share the history and beauty of Indonesia with residents and tourists. The job took her across the country to places like Lombok and Bali, and food was always a key tool in her messaging.

Astuti immigrated to the United States in 2001. She settled in Detroit and went to work in the hotel industry, hoping to combine her passions for food and travel. Not long after she arrived, she met Mulyana, who'd trained as a hibachi chef. Astuti loved the snow, as it was vastly different from her homeland, but Mulyana was less than enthusiastic about the cold climate. While Astuti enjoyed living in the city, she struggled to find Indonesian food and community. She regularly visited Indonesia to see her family, and her mother, a professional cook, explained to her that understanding how to cook Indonesian food—whether for business or personal sustenance—was essential.

"We gathered a lot [at] the table," recalled Astuti of her upbringing. "So there were a lot of

Warung's
Tilapia Goreng

WARUNG HAS BECOME A HUB FOR THE LOCAL INDONESIAN COMMUNITY, AS WELL AS FOR MUSLIM DINERS DRAWN BY THE HALAL DESIGNATION.

memories...over food, really. So every time I went back home, every couple years since 2001, I always tried to cook myself." She said her mother would tell her, "You don't have to do it like me, professionally—having employees and all that stuff—but you do have to learn how to do it at home."

As Astuti began to master Indonesian cuisine, she started to toy with the idea of opening her own restaurant. Mulyana was on board, but he was ready to leave Detroit. He suggested moving down to Georgia, specifically the Atlanta area, where a sizeable number of Indonesians had immigrated for jobs in the tech, health, and service sectors. And he was drawn to the climate, which would be more similar to the hot and humid Indonesian islands. The couple initially moved to Winder, about an hour from Georgia's capital, and then closer to the city. It's the Atlanta area where Astuti found the perfect location for her restaurant.

"Oh, this is perfect," she recalled thinking. "This is located on Buford Highway; this is where the culinaries are. People are going to look for a lot of different cuisines, and there is no Indonesian restaurant." She decided she was going to give them one.

At Warung Indonesia, Astuti aims to amplify a cuisine that's both underrepresented and misunderstood in the United States. Warung Indonesia is located in Doraville, a suburb just fifteen miles northeast of downtown Atlanta. Since the 1980s, immigrant populations have rapidly increased, making the area home to one of the largest South Asian populations in the country. An estimated 69 percent of Doraville residents speak a language other than English at home. A Bangladeshi halal butcher and grocery store is right next to Warung, and the neighborhood is filled with international

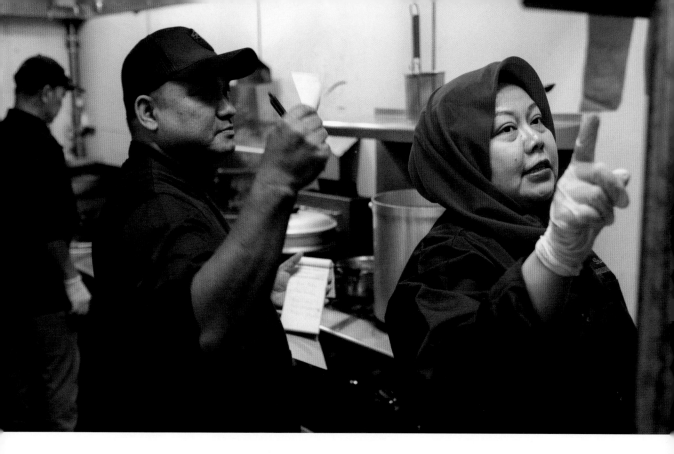

Warung co-owners Deni Mulyana and Sri Astuti check lunch orders in the kitchen.

restaurants, including Vietnamese, Indian, and Ethiopian. Warung Indonesia has quickly carved out its own niche. The restaurant has become a hub for the local Indonesian community, as well as for Muslim diners drawn by the halal designation.

Astuti remains true to the culinary skills she picked up from her mom. The beef rendang, a hearty beef stew that's one of Indonesia's most famous dishes, is bathed in coconut milk and aromatics and cooked for hours, until the beef is falling-apart tender. Satay ayam, seasoned chicken served on skewers, is cooked over an open flame, offering a smoky taste to balance the peanut sauce that covers the meaty chunks. Ikan tilapia goreng, or fried fish, is served with steamed with rice and vegetables. And there's plenty of sambal and kecap manis—staple Indonesian condiments—to go around.

Astuti was clear that Warung reflects a personal take on Indonesian cuisine. After all, she said, "Indonesia is 17,000 islands." She's not trying to tell the whole story—just the one she and Mulyana know.

According to Astuti, Indonesian Atlantans have offered an overwhelmingly positive response to their efforts.

"They're very, very proud of us," she said. "They have spread the word to family, the friends that come from out of town, so the locals actually help us out in spreading the word about us," bringing in new customers.

While the restaurant is still young, it shows the promise that has unfortunately evaded Indonesian restaurants in the United States, even in large cities. In New York, Bali Kitchen, a popular, Indonesian-owned restaurant in the heart of Manhattan's East Village, was forced to close in summer 2020, a casualty of the pandemic. In Houston, too, Indonesian restaurants have struggled with longevity. Houston's 3,000 Indonesians tend to rely instead on local home-based caterers.

Astuti hopes that her restaurant can be an anomaly, and an example of what's possible when immigrant restaurant owners stay true to their vision, values, and cuisine. So far, it's working. 🍸

Kayla Stewart has written about food and travel for The New York Times, Travel + Leisure, The Washington Post, *and other publications. She is the co-writer, with Emily Meggett, of* Gullah Geechee Home Cooking: Recipes from the Matriarch of Edisto Island, *forthcoming from Abrams in April 2022.*

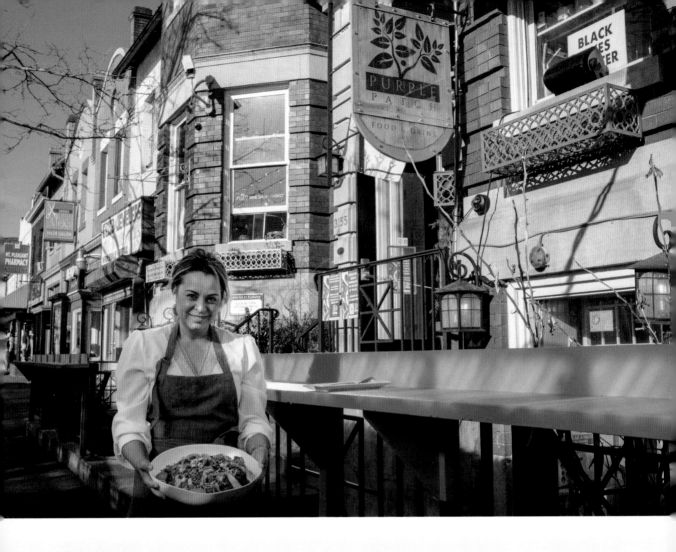

PURPLE PATCH:
My Home away from Home

I went looking for a neighborhood spot to call my own.
I found a taste of my family's history.

by **LINDA GOLDEN** *Photos by Susana Raab*

My husband and I moved to Washington, DC, in June 2015

and settled in the Mount Pleasant neighborhood in July. As we explored our new home, we looked for a restaurant where we could be regulars, chasing a dream of our own Cheers, where everybody knew our names. In October, *Washington Post* food critic Tom Sietsema included the Filipino American restaurant Purple Patch in his fall dining guide. We visited, then returned again and again, until Purple Patch became our go-to, a second home, the place we took all our friends and visitors, our Friday night happy hour that turned into dinner.

Part of the draw was proximity. The restaurant sits midway down Mount Pleasant Street, the neighborhood's main street, a short walk from our apartment. A happy hour that lasted until eight, an hour later than many places, helped. We'd sit at the bar, crowding in with other patrons—young, old, Filipino, Black, white, Latino, folks on first dates, friends catching up—as larger parties and families filled the tables in the back half of the restaurant. We'd order beers, adobo wings, five

crispy lumpia, the golden wrappers flaking as we bit through the spring rolls to the pork and beef inside. Sometimes we split the sizzling sisig, the cast-iron platter of chopped pork shoulder and belly arriving in a cloud of chile-infused smoke.

Patrice Cleary, Purple Patch's owner and chef, often circulated, checking in with her staff, visiting tables to greet guests, asking about their meals. She listened as, over their halo-halo dessert, an older Filipino woman and her friend told her

LEFT: Patrice Cleary, owner of Purple Patch in the Mount Pleasant neighborhood of Washington, DC. She holds a bowl of her signature Pancit Mahal, a noodle dish. BELOW: The author's great-grandfather Generoso Siapno with employees at his diner in Norfolk, VA, ca. 1930s. (Photo courtesy of Linda Golden)

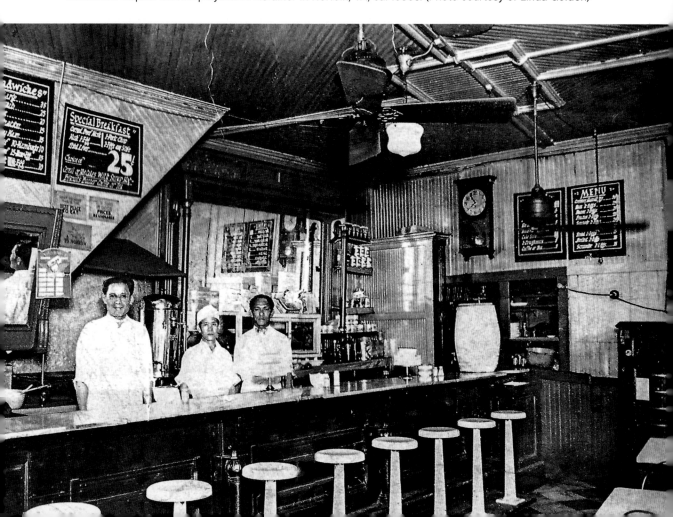

When we visited Purple Patch with my parents and my cousins, there was the knowledge that up our family tree, someone cooked like this.

about driving in from Virginia to try the food. She thanked people for coming. A United States Marine Corps veteran, Cleary, now forty-eight, opened Purple Patch after years in the service industry, bartending and catering. Her presence—along with the food, and the bartenders who did indeed ask our names (even if, unlike Sam Malone of Cheers, they forgot them between visits)—made Purple Patch an easy favorite.

Purple Patch's take on Filipino cuisine spoke to my own family history. My Filipino great-grandfather, Generoso Siapno, was born in Dagupan in 1889. Thirteen years later, the United States established a naval base at Subic Bay and began recruiting Filipinos as guides and mess attendants. The base operated until 1992 and was one of the Philippines' largest employers. Generoso joined as a steward at age twenty. He ended up in New Orleans and married Lithia Russell, a Louisianan woman whose own grandfather was Filipino. In the 1930s and 40s, they raised my grandma, great-aunt, and great-uncles in Norfolk, Virginia, home

to the world's largest naval base. When he left the Navy, Generoso studied to be an electrician. But he ended up running a diner, the Manila Cafe, in Norfolk for close to a decade. Our family has one photograph of Generoso at his café. In it, he stands behind the counter with two friends who worked with him. We know them only by their first names, Padja and Casheano. Menu signs on the wall above them advertise sandwiches: large club, small club, country ham. A 25-cent special breakfast comes with a choice of corned beef hash, hash and egg, fried liver, one pork chop, or two eggs. Only the men cooking and serving the food are Filipino.

Our Siapno family cookbook includes one recipe for "bean thread (sotanghon)." It's not a dish I recall from my Texas childhood. My dad, raised by a Norfolk Siapno and an Illinois Golden who served as missionaries, grew up all over Africa. His cooking trended more Virginian and West African—black beans and sausage, collards with kippered herring, okra and beef cubes, and rice, always rice. My Swiss mother made ratatouille, spaghetti, and a macaroni-and-cheese casserole with frozen vegetable medley and hot dogs. When we ate out, we went to Mexican, Chinese, Belgian, and Brazilian restaurants around Dallas and Houston. We attended extended family gatherings infrequently; the last one I recall was in 1989 in Virginia Beach. At five years old, my interests included playing with cousins and avoiding jellyfish. The Siapno siblings gathering around a bushel of blue crabs—that's the culinary picture I conjure for that part of the family.

In 2015, when my husband and I arrived in DC, the remaining Siapno siblings were in decline. Within a year, my great-aunt Marjorie, the oldest of Generoso's five children, died. My grandmother Clara, Marjorie's sister, passed soon after. My aunt ordered trays of lumpia and pancit (noodles) for my grandmother's funeral reception. It is the only time I remember eating Filipino food with my extended family.

I have questions for my grandmother and great-aunt. What was it like growing up as Filipino American women in segregated Virginia? Apart from that one dish in the family cookbook, what

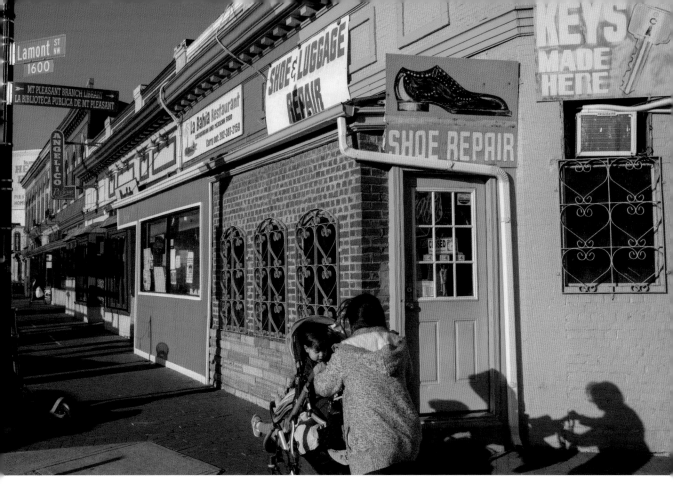

ABOVE: The intersection of Lamont and Mt. Pleasant streets near Purple Patch, February 2022. The area has been home to thriving immigrant communities and immigrant-owned businesses since the 1970s.
OPPOSITE: Purple Patch Filipino Restaurant on Mt. Pleasant St NW. In the foreground is the outdoor dining space, erected in the early months of the COVID pandemic and still in use.

Filipino food did they eat growing up? Yet by the time I became curious, it was too late.

As that first year of funerals, memorials, and home-clearings faded, Purple Patch, my neighborhood Filipino restaurant, became a link of sorts to that part of the family. When we visited the restaurant with my parents and my cousins, there was the knowledge that up our family tree, someone cooked like this. Someone taught the Siapno kids to make sotanghon.

When she opened Purple Patch, Patrice Cleary intended to foster this very sense of shared Filipino identity among a segment of her clientele. "The reason why I do what I do is because the memories that you have will just be memories if there weren't people like me and other pioneers in this industry for Filipino food," she told me. We sat at a table outside her restaurant one afternoon last fall. A cloth face mask hung from a chain around her neck, and her long, highlighted black hair fell around her shoulders. Since the start of the pandemic in March 2020, the restaurant, once housed in the basement and first floor of a DC rowhouse, has spilled onto Mount Pleasant Street. A wooden shelter topped with plastic corrugated roofing corralled the outdoor seating. The makeshift patio stretched beyond Purple Patch's entrance toward its neighbors on either side: the unisex hair salon, a jewelry store, a nail salon, the Salvadoran chicken place. Artificial ivy and pink roses snaked around the shelter's rafters and up support pillars, between which hung baskets of live petunias and begonias. Gauzy curtains blocked the late-afternoon sun. A server stopped by our table to offer us frozen calamansi juice, made from the sweet-sour Filipino citrus fruit that appears both on the drink and dinner menus.

I told Cleary that I have no memories of my great-grandfather, nor of eating Filipino food in my childhood. "You have Filipino lineage," she replied. "And so even though you don't have that

memory, now I'm helping you create it."

"There's so many memories I have from my mom making food when I was a child, and there was never a recipe that she passed on to me," Cleary continued. "It was always just, 'Oh, it's a little bit of this, a lot of that, and a little bit of this,'" her words echoing those of so many cooks trying to replicate family dishes with direction from a tablespoon-averse elder. Cleary converted her memories into measurements and created recipes when she opened Purple Patch.

"I didn't have this growing up," Cleary said, gesturing at her restaurant. "My mom built a little piece of it at home, but whenever I asked my mom to open up a restaurant, she shied away from it."

Cleary doesn't recall Olangapo, her birthplace in the Philippines. Her own memories start in Westwood, Massachusetts, her American father's hometown, where the family moved when she was young. Cleary remembers her mother Alice's efforts to share Filipino food with Americans. She focused on dishes friendly to the American palate, like chicken adobo, lumpia, fried rice, and pancit.

"Those four dishes I remember my mom making for every party, every festivity, because she knew that anybody would love this food," Cleary said in an oral history recorded for the DC public library.

Cleary's father's military career took the family around the world. They lived in Japan, Korea, the Azores, and all over the United States. Alice catered for restaurants on the bases. She also set up a stand in the airplane hangars where her husband worked as an aviation electronics technician. She sold plates of pancit, lumpia, barbecued meat, and white rice. She enlisted her children's help, and Cleary remembers assembling lumpia with her two siblings.

It would be a while before Cleary made lumpia alone. When she was seventeen, her father died. At eighteen, she enlisted in the United States Marine Corps. She spent eight years in the Marines, then worked for a venture capital firm in DC, then in New York. She quit and returned to Washington in 2001.

"I realized I did not want to inbox anymore, and I said, 'I want to become a bartender.'"

BELOW: Lumpia stuffed with pork and beef are served with banana ketchup and spicy vinegar dipping sauces.
RIGHT: Purple Patch's cocktail offerings include a nonalcoholic strawberry spritzer and rum-spiked spiced cider.

Cleary made flashcards, studied them, and helped at a friend's bar until he offered her a paid shift on Thanksgiving. This was the start of her service-industry career. After giving birth to her first son, she stayed at home but began selling savory hand pies and lumpia on the side.

"It wasn't really about making money. It was more so about just keeping my brain active," she said.

In 2014, Cleary returned to Mount Pleasant with her then-husband to open Purple Patch in the space previously occupied by Tonic, a restaurant she'd helped friends start years earlier. When Purple Patch opened in March 2015, it was the first new Filipino restaurant in the capital in years. Despite a slew of early challenges, she refused to give up: not when the restaurant flooded a month in; not when she fired her first chef after three months because he did not understand her vision; not when, after only six months, both her husband and their accountant told her the restaurant would never make money and that she should quit.

"I said, 'You've got to give me time...but six months just isn't enough time.'"

Six years, a divorce, and a pandemic later, Cleary has shown herself—and everyone else—that she could do it, overcoming logistical challenges and self-doubt. When she opened Purple Patch, Cleary had no connections to the local Filipino community and worried about criticisms of not being authentic.

"Am I Filipino enough? The only person that can make me Filipino enough is me. And it's taken me opening a restaurant to believe in that and see that I am Filipino enough for me."

If you've heard about Filipino food in DC, it's likely by way of Bad Saint, Purple Patch's nationally recognized Columbia Heights neighbor. But Filipino restaurants existed around the capital before these two restaurants, serving the more than 97,000 Filipinos in the DC metropolitan area. There were smaller, turo turo spots (literally, "point-point": restaurants with steam tables where you point at the food you want), bakeries, counters

in grocery stores, and buffets in strip malls.

A similar scene developed in Norfolk, my Filipino family's home.

"There were a couple of Filipino grocery stores, you know, turo turo style, point-point, but I don't remember any standalone restaurants," said Gem Daus of the Filipino food scene in Norfolk in the 1970s and 80s. Daus, who teaches part-time at the University of Maryland and William and Mary's Asian American Studies programs, was born in the Philippines and moved to Norfolk in 1972 when the Navy posted his father there. He said the current Filipino restaurants are a product of the generation that grew up in the United States.

"They've adopted this profession, maybe, after doing the profession their parents wanted them to do," he said. Daus also pointed out that because many Filipinos had jobs in the Navy or medical fields, restaurant work was an avoidable profession. Now, the children of immigrants are opening restaurants to showcase the food they grew up with at home.

Cleary refused to give up—not when the restaurant flooded a month in; not when she fired her first chef; not when, after only six months, both her husband and their accountant told her that she should quit.

Rita Cacas, coauthor of *Filipinos in Washington, D.C.* and creator of the University of Maryland's Filipino American Community Archives collection, wondered why Filipino food, which she'd been eating all her life, was suddenly so popular. One reason it was slow to gain recognition, Cacas thought, was the fault of her mother's generation.

"Everyone said, 'I don't like this food. My pancit's better.' Nobody wanted to support their community, so things failed," Cacas said of the attitude when she was growing up.

Of the recent rise of Filipino restaurants, Daus said, "We stopped asking for authenticity and just started asking, 'Is it good?'"

At Purple Patch, the menu has always been Filipino American. The beef section features coconut-braised short rib adobo, a cheeseburger, and a ribeye steak. The sizzling pork sisig also comes in burrito form. Cleary's attention to her customers goes beyond the food and the restaurant walls. When the pandemic hit, Cleary shut down Purple Patch for a day and quickly charted a new course. She and her staff converted the upstairs dining room into a pick-up area for takeout orders and a market selling Filipino snacks and desserts. She cooked trays of food for healthcare workers and offered free lunch for neighborhood children.

"The program still exists," she said. "We don't really have anybody coming in any more for it, but we've done well over 6,000 meals."

She continues to donate breakfast to an outdoor Saturday morning concert series for children in the neighborhood.

Of the growing list of Filipino restaurants in the area, Cleary said, "I have nothing but love for my fellow chefs and my fellow restaurateurs. So much so that all of us, we tend to cook together a lot now."

For the last few Octobers, Filipino American month, Cleary and other chefs, including Paolo Dungca and Tom Cunanan of Pogiboy (formerly of Kaliwa and Bad Saint, respectively), Javier Fernandez of Kuya Ja's, have collaborated on a Taste of

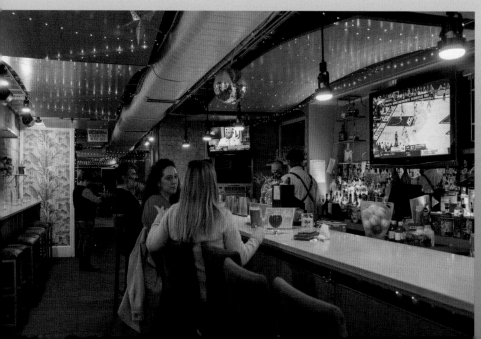

LEFT: Purple Patch bar patrons, February 2022. ABOVE: Patrice Cleary with (l to r) Pancit Mahal, fried spicy adobo wings, and lumpia—three of her most popular dishes.

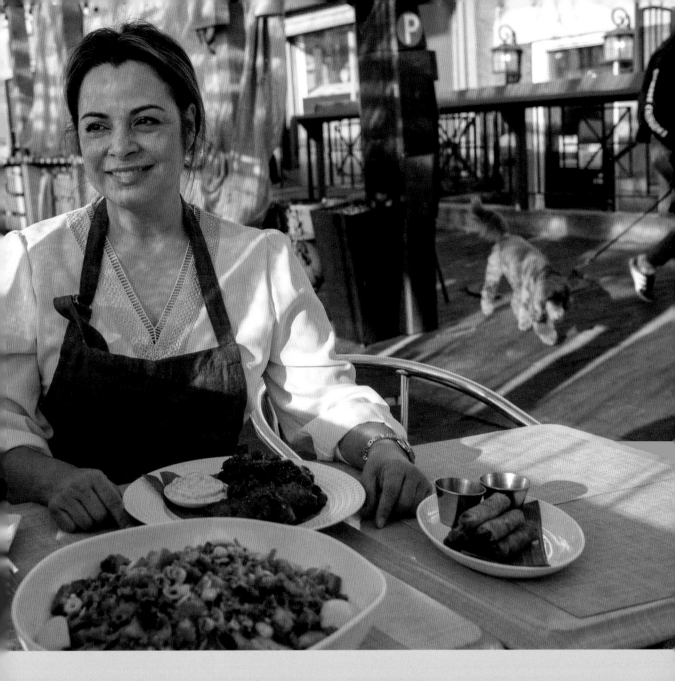

the Philippines dinner, each contributing a dish to a tasting box.

Through Purple Patch, Cleary found community. "I have developed this new family that has been brought together by food," she said. "And it was a part of me that was missing for so long that I never realized it. I never realized how good your own people make you feel."

Now, she aims to share that feeling. "I want to have a place of comfort and familiarity when Filipinos come here, because this isn't just a restaurant for the neighborhood," she told me. "I want families to come here and be able to have celebrations and to order food that brings them fond memories of their childhood."

Filipino food isn't part of my childhood memories, and I will never get to eat my great-grandfather's cooking. Patrice Cleary and Purple Patch gave me a place to make memories: of visits with family and friends, of birthday and anniversary celebrations, of reunions and goodbyes. Cleary introduced me to laing, a thick, coconut milk–based stew full of taro leaves, ginger, and chile peppers; to fried chicken adobo, the skin drenched with soy and vinegar. In a year without family, Purple Patch gave me a sense of connection to mine, and a taste of shared history. 🍸

Linda Golden eats, reads, writes, and bikes around Washington, DC.

From Latino
ORLANDO
to International
MEMPHIS

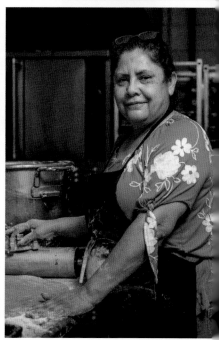

Foodways, dissent, and the politics of place

by SIMONE DELERME

Photos by HOUSTON COFIELD *and* ROBERTO GONZALEZ

For over a decade,

I've been documenting the cultural, political, and economic transformations that Latino migrants have brought to Southern communities. I'm particularly interested in changes to landscapes and soundscapes. In places where I've conducted fieldwork—Florida, Tennessee, and Mississippi—the number of Latino-owned businesses has increased over the last thirty years. These businesses tend to be concentrated in commercial spaces where Spanish-language advertising and storefront signs create a distinctive cultural landscape, and the Spanish language can be heard as frequently as, if not more frequently than, English.

Buenaventura Lakes (commonly shortened to BVL), a suburb in Osceola County, Florida; and Summer Avenue, a six-mile-long commercial district in urban Memphis, Tennessee, experienced an influx of migrants in recent decades. In both cases, newcomers introduced new restaurants, markets, and food stands. And in Florida in particular, existing businesses pivoted to serve changing tastes. The evolving culinary landscape held different meanings for incoming and receiving residents. Some residents saw these businesses as evidence of the migrant population's successful incorporation into the community, as a means for maintaining Latin American and Caribbean foodways in the US South, and as an opportunity for community revitalization. For others, the changing foodways served as an unwelcome reminder that the population was now majority Latino.

When I moved to BVL in 2010, the process of Latinization was already well underway. Puerto Ricans and other Latinos migrated to central Florida in large numbers several decades before my arrival. As a result, the landscape and soundscape already reflected the Latino presence. In Osceola County, one of four counties in Greater Orlando, the proportion of Latino residents increased from 2.2 percent in 1980 to 45.5 percent in 2010. By 2020, Latinos were over 50 percent of the county's total population and numbered approximately 211,089. The growth of both small and large Latino-owned establishments, where business was conducted primarily in Spanish, made it evident that the Puerto Rican diaspora had already reached a critical mass.

In his book, *Divided Border: Essays on Puerto Rican Identity,* Juan Flores described the similarities

RIGHT: An assortment of baked goods at La Espiga Panadería on Summer Avenue in Memphis, TN

Houston Cofield

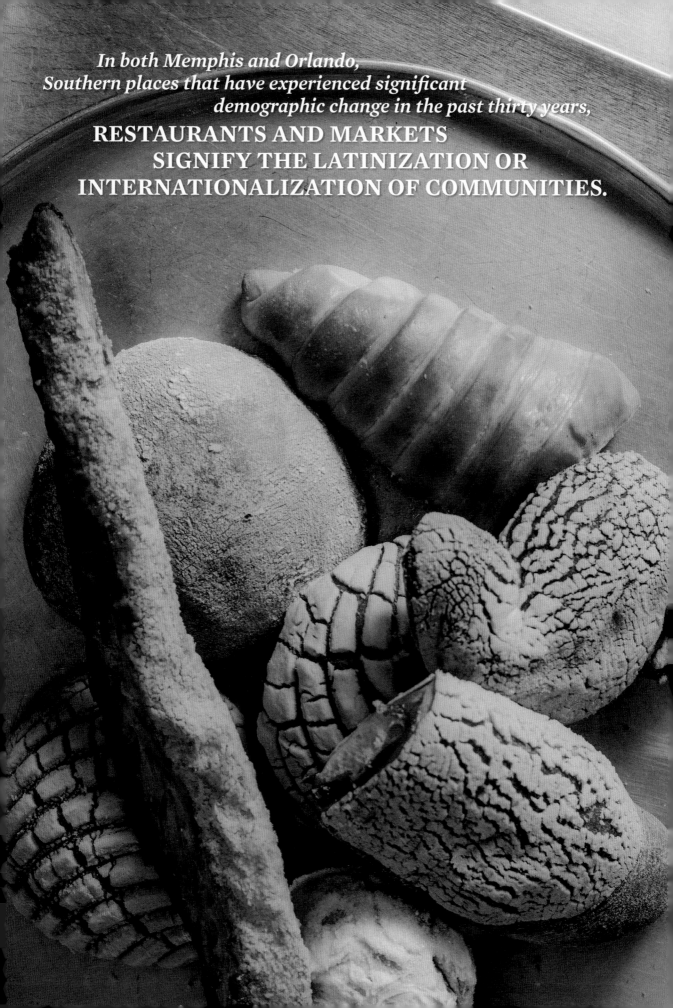

In both Memphis and Orlando,
Southern places that have experienced significant
demographic change in the past thirty years,
RESTAURANTS AND MARKETS
SIGNIFY THE LATINIZATION OR
INTERNATIONALIZATION OF COMMUNITIES.

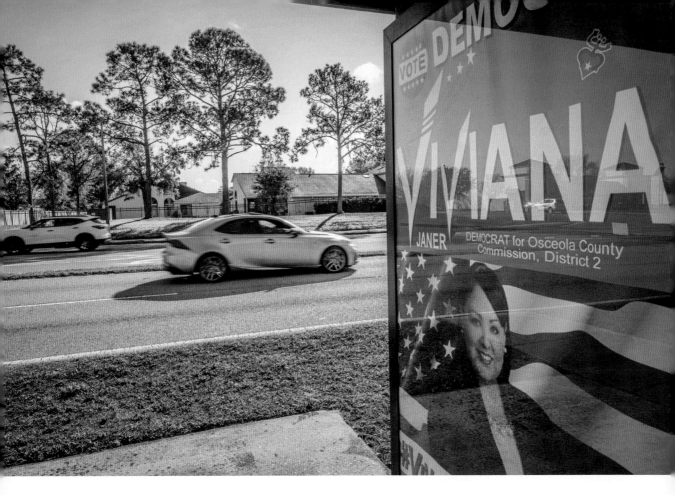

A bus stop in BVL displays a campaign ad for Viviana Janer, a Puerto Rican running for re-election to the Osceola County Commission, February 2022.

between Los Angeles and New York's huge Spanish-speaking neighborhoods. In these two urban spaces, he wrote, "all of your senses inform you that you are in Latin America, or that some section of Latin America has been transplanted to the urban United States where it maintains itself energetically." In the suburbs of Greater Orlando, I found that the Puerto Rican diaspora was already influencing political, economic, and cultural life.

Puerto Ricans are the largest group of Latinos in Greater Orlando, and the wave of migration in the 1990s through the early 2010s included both professionals and low-paid service sector workers. Multiple push-pull factors fueled and sustained the migration, including real estate marketing and opportunities for homeownership; labor recruitment; powerful social networks (a phenomenon known as "chain migration"); and the perception that Florida offered a better quality of life. For upwardly mobile Puerto Ricans, central Florida offered greater economic promise in a similarly attractive climate. Push factors from the island included the social consequences of Puerto Rico's

economic instability, such as rising crime rates and the fear of violence. Additionally, deindustrialization in the United States during the 1970s led to layoffs of Puerto Rican workers living in Northern cities and contributed to outmigration to other parts of the country, including Florida. Since Puerto Ricans are United States citizens, they are able to avoid some of the social and political barriers faced by foreign-born immigrants. By 2010, the population's growing political power and cultural influence was evident.

Sandra Lopez (an alias), a schoolteacher from New York City who had relocated to BVL, recalled driving into Orlando to find Latin American and Caribbean products in the late 1980s. "It took between forty-five minutes to an hour to get plátanos [plantains] or pernil [roast pork]. As time progressed, the food changed." Food, she explained, was a measure of the demographic transformations. "Eventually the supermarket created an international food aisle and you knew that was your section." Over time, entire supermarkets replaced the single international food aisle. Some of these restaurants and markets took

Buenaventura Lakes (BVL) in Osceola County, FL, identifies as 76 percent Latino.

the place of existing establishments that once catered to non-Latino white residents.

In 2005, the Publix supermarket chain opened a standalone market called Publix Sabor in Osceola County's Kissimmee. All product information and signs were bilingual, and the store offered a wide variety of Latin American and Caribbean products. Plátanos maduros (sweet plantains), empanada dough, and a selection of frozen Goya dinners—arroz con pollo (rice with chicken), ropa vieja con arroz (rice with shredded beef), and arroz con gandules (rice with pigeon peas)—were just a few of the products that lined the freezer shelves.

For some residents, the availability of familiar Latin American and Caribbean foods was central to their sense of being at home in a new place. For others, the Latinization of grocery shelves was a daily reminder that BVL was changing and non-Latino white residents were becoming a demographic minority for the first time.

On a hot summer day in July 2010, I stood outside of the Robert Guevara Community Center in BVL, named after the first Puerto Rican elected to the Osceola County Commission, and listened as a small group of non-Latino residents discussed their frustration with the local supermarkets and businesses that they saw as "catering" to Latino consumers. One mentioned his experience in a local supermarket where several store associates had to look around to find an English-speaking worker to assist him, while he waited patiently in disbelief. Another resident chimed in and mentioned another supermarket, Sedano's, which had opened earlier that year in the same space as her former grocery store.

Founded in 1962, Sedano's initially catered to a Cuban American clientele. It grew to a chain of about thirty-five Florida markets. Salsa music played, pastelitos (a pastry baked or fried with sweet or savory fillings) were available in a café, and clerks greeted customers in Spanish, although signs were in English. In 2009, Sedano's purchased three Albertsons markets in Central Florida with plans to serve the growing Puerto Rican customer base. The new Orlando-area Sedano's stocked brands like Iberia, Conchita, and El Norteño. Augusto Sanabria, president and

Roberto Gonzalez

chief executive officer of Prospera (formerly the Hispanic Business Initiative Fund), told a journalist at the time, "Anytime that a big Hispanic company comes into town, it just re-emphasizes the power of the Hispanic community here in Central Florida.... It's music to my ears."

Yet not everyone celebrated the arrival of Sedano's. On January 8, 2010, an Internet user who went by the name of tim (sic) commented on an *Orlando Sentinel* article about the new chain. "Hispanics need their own supermarkets...wow!...the regular supermarkets are not good enough for them??"

Supermarkets and formal businesses weren't the only signs of Greater Orlando's changing culinary landscape. When I drove around BVL on weekends, I encountered garage sales, yard sales, and poster boards advertising the sale of alcapurrias (a fritter made from plantains and stuffed with meat), empanadas, or pinchos (meat kabobs). These types of "plate sales" are common in other parts of the South. My neighbor consistently set up his grill on the front lawn, arranged folding chairs, and prepared pinchos to sell when cars pulled over and neighbors congregated.

Life had clearly changed since the 1980s, when Sandra Lopez had to travel forty miles for familiar Puerto Rican foods. In BVL, the concession stand at the Archie Gordon Memorial Park sold empanadas and pernil sandwiches while the cashier behind the counter blasted salsa music on a radio. I was even able to purchase pasteles during the holiday season from a vendor in the local Walmart parking lot. (Pasteles are a traditional Puerto Rican dish. Labor-intensive to prepare and usually associated with the Christmas season, they are made of a root-vegetable masa stuffed with meat and boiled in a plantain leaf.)

I quickly learned that while some of my interviewees appreciated the availability of familiar Caribbean foods in residential spaces and commercial parking lots, other residents interpreted this practice as a health-code violation and as evidence of unwelcome cultural changes. The suburb they had called home for decades now felt foreign. When I began my research in Florida, my focus was not on foodways. Yet restaurants and markets emerged as important sites of contestation, and I continued to pay attention to them.

Andrew Gattas owns Knowledge Tree, a school-supply store on Summer Avenue in Memphis. He is the second generation in his family to own a business on Summer Avenue.

Summer Avenue in Memphis, Tennessee, is another Southern landscape that has changed dramatically over the years. The avenue was the location of the first Holiday Inn in the United States as well as the first McDonald's in Memphis. In the mid-twentieth century, Summer was lined with restaurants and motor courts, and there was a thriving business district. In recent decades, the area became home to a sizable immigrant population. Latinos made up a large portion of this growth. New immigrants to the Summer Avenue corridor opened businesses of all kinds, but especially restaurants and grocery stores.

Caiman Authentic Venezuelan Cuisine and Bakery, which I visited several times in the summer of 2017, was an important social space for Venezuelan Memphians to gather, converse about Venezuelan politics, and enjoy cuisine that reminded them of home. Caiman owner Allen Ampueda left Venezuela in 2004 and arrived in Arkansas, where his sister was living. He found work remodeling houses and repairing semi-trucks until his sister put the idea of a restaurant in his head. Eventually, he moved to Memphis and opened Caiman.

(The restaurant has since closed.)

During one visit, a customer named Maria told me that she came to Caiman when she was having a difficult day. She took out her cell phone to show me a photo of a bullet-riddled house that belonged to someone she knew back in Venezuela. Maria left the country because she feared for her life. "It's a dictatorship—they want the oil. Venezuela is a rich country. They imprison anyone who opposes," she said. Her family is now scattered around North America and Europe. Maria only needed to complete a few more credits to earn her master's degree, but she couldn't feed her children on her teacher's salary. She described herself as an activist and wanted me to understand that the people in Venezuela were suffering. She continued her activism as best she could from her new home in Memphis.

In 2018, the Summer Avenue Merchant Association initiated an effort to brand the avenue as Memphis' official "International District," naming a roughly three-mile section of Summer between Highland Street and White Station Road "Nations Highway." Restaurants and markets in particular

A house in Buenaventura Lakes (BVL) displays a flag for a free Cuba. While Puerto Ricans make up a large percentage of BVL's population, the area is also home to other Latino communities, including Cuban Americans.

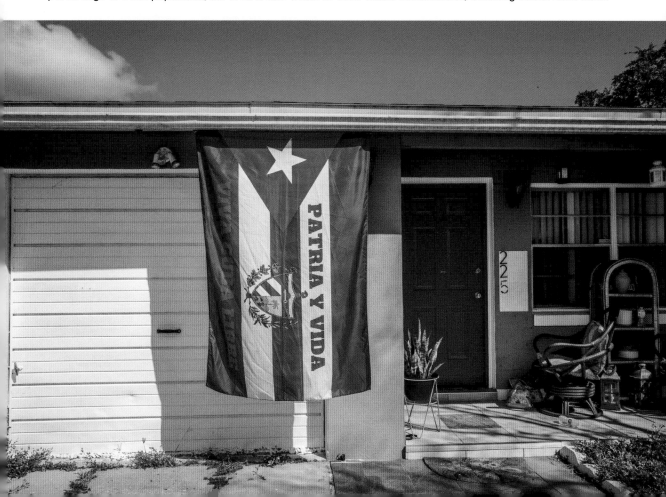

An employee behind the bar at Mi Tierra on Summer Avenue in Memphis, September 2021.

became key to that international place-identity. In a 2018 article from *High Ground News*, Meghan Medford, the association president, explained that "Summer Avenue used to be the place where everyone wanted to go to, where everyone hung out.... We're trying to bring that energy back to Summer." She later told me, "There's just so many different nationalities and countries represented here, and you can get any kind of food from anywhere. And so we were thinking, what is this area and what does it mean to people?"

White flight to the suburbs following the desegregation of Memphis public schools may have paved the way for new immigrant populations to transform Summer Avenue, Meghan said. "A lot of the immigrants moved into those houses that are in the area, and they rented them. And it's an area that welcomes everyone and they felt comfortable," she said.

Andrew Gattas, owner of the school-supply company Knowledge Tree, spent much of his childhood and adolescence working for the department store his father opened on Summer Avenue in 1970. He reflected on the transformations he witnessed over the years. "I didn't really fully understand the impact until probably five or six years ago, when you drive down and you genuinely see every type of ethnic restaurant you could imagine..." he said, clarifying, "I think it had happened long before that, long before I noticed."

Abdullah Mohammed, a merchant from Taiz, Yemen, who opened the Stone House Market in 2016, described the changes he witnessed along Summer Avenue. He decided to open his business because he saw Latinos, Yemenis, Iraqis, and Palestinians in the area. It looked like it was going to be an international street, he explained. He went on to name a Turkish grill, a Japanese restaurant, an Iraqi investor, a Jordanian laundromat owner, a Mexican immigration attorney, and a furniture salesman from Jerusalem. "Now the street is just an international place," he said.

Mirna Garcia, co-owner of Mi Tierra Colombian and Mexican restaurant, recalled that in 1995 the Latino community was very small. When her restaurant first opened nineteen years ago, it only sold Colombian food, but "customers would look in and they'd look and they loved the place, but

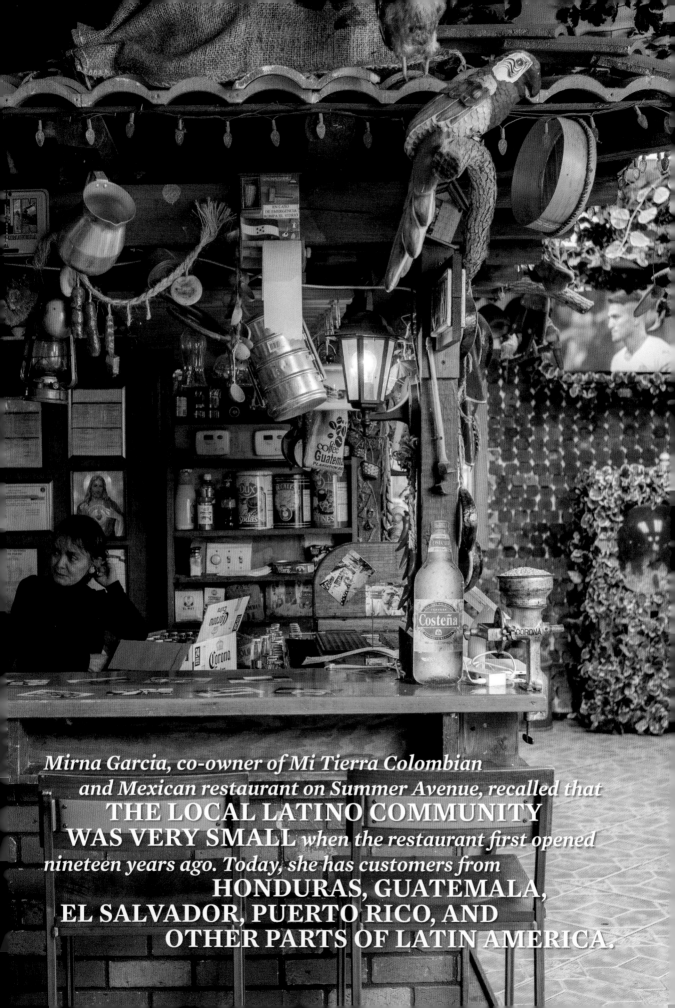

Mirna Garcia, co-owner of Mi Tierra Colombian
and Mexican restaurant on Summer Avenue, recalled that
THE LOCAL LATINO COMMUNITY
WAS VERY SMALL when the restaurant first opened
nineteen years ago. Today, she has customers from
HONDURAS, GUATEMALA,
EL SALVADOR, PUERTO RICO, AND
OTHER PARTS OF LATIN AMERICA.

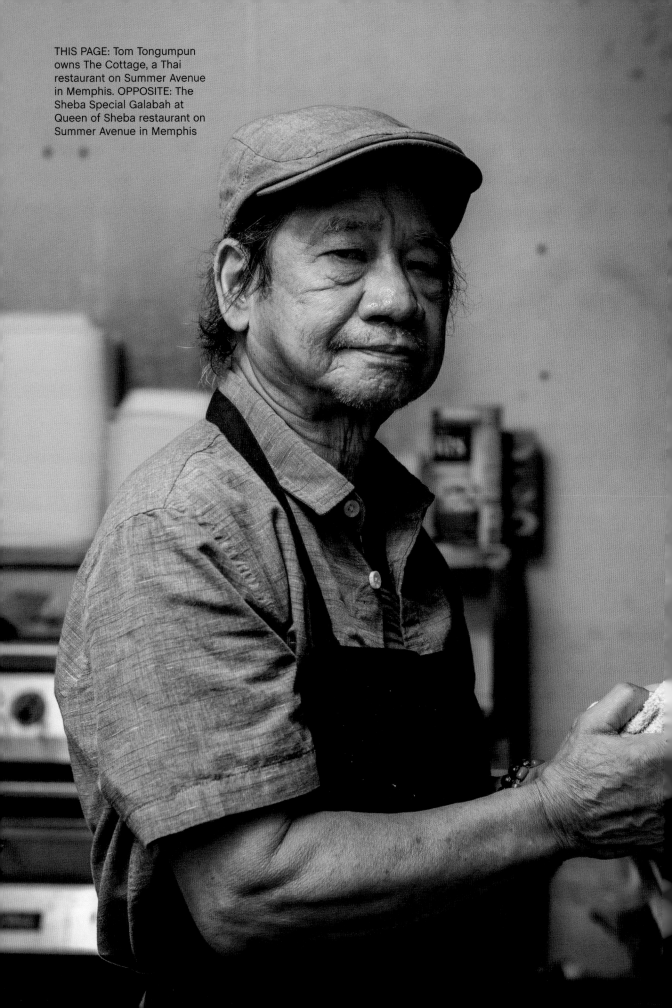

THIS PAGE: Tom Tongumpun owns The Cottage, a Thai restaurant on Summer Avenue in Memphis. OPPOSITE: The Sheba Special Galabah at Queen of Sheba restaurant on Summer Avenue in Memphis

they were not adventurous enough to try the food, so they would leave.... So we added Mexican food to the menu, and that started letting customers stay trying the Mexican food and also try the Colombian. Now they come back and just order the Colombian." Garcia has customers from Honduras, Guatemala, El Salvador, Puerto Rico, and other parts of Latin America.

The Summer Avenue Merchant's Association embraced and promoted the different ethnic groups that contributed to the revitalization of the area. In 2018, local newspapers mentioned a $50,000 Community Enhancement Grant the association received from the county. Heidi Shafer, a former Shelby County commissioner, told the press that "we've really been trying to bring Summer up for about a decade now.... One of the things I thought would be helpful is if we could start to give Summer a sense of place." The first phase of the project was the installation of banners that said "Nations Highway" and displayed flags from different parts of the world to demarcate the space. The second phase would focus on landscape design and other beautification efforts.

What happened next surprised me. Controversy over the branding effort emerged from within the international community and quickly became a topic of debate on social media and in the local press. Residents questioned whether there was an equal investment in the surrounding community. At least one person expressed fear that the increased attention would make Summer Avenue businesses the targets of raids by Immigration and Customs Enforcement. Another criticized the effort as a project of "neoliberal multiculturalism," arguing that the international identities of the business owners and the diversity they brought to the commercial strip was being exploited for marketing purposes and profits. Some saw the project as catering to tourists rather than neighbors.

The branding initiative received additional criticism from both native Memphians and members of the international community who objected to the banners that were placed on poles along the avenue. Each pole featured a flag from a different country. According to some reports, the local Vietnamese population wanted the yellow flag that represented South Vietnam on display instead

of the red flag that represented North Vietnam before being adopted as the countries unifying flag. I later learned that the banner with the Vietnamese flag was torn down. The Chinese flag was also challenged for having communist symbolism, while the Israeli flag was criticized because the Jerusalem Market was owned by Palestinians. All of the flags were eventually removed.

In 2021, the Tennessee Department of Transportation awarded an urban transportation grant to the City of Memphis' Division of Planning and Development to create a Complete Streets Plan, which would guide Summer Avenue's future development. The design renderings stood in stark contrast to the modest strip malls that currently line the avenue. Those improvements would certainly improve the aesthetic, and perhaps they will transform Summer Avenue into the destination space that many business owners hoped for. However, I couldn't help but think of the opposition to the infrastructural changes and the emphasis on gentrification. There was fear that rents would increase, potentially pushing some businesses to close.

In Memphis, Tennessee, and Orlando, Florida—Southern places that experienced significant demographic changes in the past thirty years—restaurants and markets signal the Latinization or internationalization of communities. Migration, food, and the identity of place are deeply bound together. And this phenomenon is occurring, or has already occurred, in so many places across the South. Perhaps even in your own backyard. 🍷

Simone Delerme is an associate professor of Anthropology and Southern Studies at the University of Mississippi.

THIS PAGE AND PREVIOUS PAGE: Houston Cofield

BACK TO THE FUTURE

Better Fresh is not your grandpa's farm.

BY ALISON MILLER

Photos by Ben Gray

GRANT ANDERSON STANDS OUTSIDE THE warehouse in downtown Metter, Georgia, where he runs Better Fresh Farms, tending to catfish filets frying in a cast-iron skillet over a propane flame. It's the day before Thanksgiving. He and his five employees have completed their deliveries to Savannah and Bluffton, South Carolina, and he's promised them a homemade lunch and an early end to the day.

Through the open garage doors, past the pickup trucks parked on the concrete floor, five

Grant Anderson, founder of Better Fresh Farms in Metter, GA, harvests black magic kale in one of his hydroponic container farms. He cuts the leaves by hand so that the plants can continue to produce for up to nine months.

climate-controlled shipping containers act as self-contained farms for the mélange of leafy greens Better Fresh provides to local restaurants, grocers, and residents who stop by or order from the Statesboro Farmers Market.

Inside each windowless 40-by-8-by-9.5–foot cuboid, roots soak in nutrient-rich water and vine-like LED lights deliver a flawless photo-synthesis glow. In a town surrounded by 25,000 acres of peanuts, corn, and cotton, this warehouse offers a glimpse into the future of farming. Grant, who grew up in nearby Effingham County, may as well be Marty McFly in work boots.

"Controlled-environment agriculture" is a term you're bound to hear more as we charge through the twenty-first century. From sprawling glassy greenhouses to forty-foot container farms like Grant's, indoor growing facilities exponentially increase yield, without pesticides, often in a fraction of the space of row crops. Many of them don't even need soil. Hydroponic set-ups use as much as 90 percent less water, and they can produce food fifty-two weeks a year, which means consistent employment for workers.

Indoor farms promise year-round food security in the face of climate change, resource scarcity, and increased demand. Well-funded startups have built behemoth greenhouses near New York City, Chicago, and Washington, DC. But they're also setting up in places where industries like coal and steel once powered the economy. AppHarvest's flagship greenhouse—irrigated entirely by rainwater—spans a swath the size of forty-five football fields in Morehead, Kentucky. This spring, New York City–based Bowery Farms will start growing baby butter lettuce, arugula, kale, and herbs inside a new facility built on a former Bethlehem Steel brownfield in Pennsylvania's Lehigh Valley.

Six container farms now comprise Better Fresh Farms in Metter, a blip off I-16 between Macon and Savannah. South Georgia is filled with small communities like this one, where commercial farms produce commodity crops to be shipped across the country and the world. "We're an ag community that's isolated from fresh food," Grant says. He believes container farms can invigorate rural areas while increasing access to local produce, picked at peak flavor and quickly distributed.

Food miles offer a useful, if imperfect, measure of freshness and carbon footprint. By the time

a head of romaine arrives in Georgia from California or Arizona, where nearly all the lettuce consumed on the East Coast is grown, it has spent several nights in refrigerated storage and traveled 2,500 miles by truck.

Grant has met some resistance. "I get a lot of comments like, 'This isn't how God meant for stuff to be grown,'" he says.

Indoor farms aren't going to replace commercial row cropping any time soon, if ever. But they may just be the vehicle to bring the South's agrarian past to the future.

But he's also heard former Husk Savannah chef Tyler Williams declare his salad the best around (Better Fresh has delivered weekly to Husk since its opening in 2018). He even ships kale to a customer in Maryland, who insists she's never tasted anything better.

Indoor farms aren't going to replace commercial row cropping any time soon, if ever. They focus on small plants with short growing cycles—salad greens, herbs, tomatoes, cucumbers, strawberries, and peppers—that net multiple harvests a year. But, Grant has discovered, they may just be the vehicle to bring the South's agrarian past to the future.

IN 2015, GRANT, then thirty-one years old and working as a payroll and benefits administrator, was eating lunch at his desk when he clicked on a *CNN Business* article about Corner Stalk Farm in Boston, a year-round hydroponic farm run by two people with no previous agricultural experience.

Reading the story, he felt a pang for his childhood. He thought of the half-acre plot he tilled and planted alongside his grandparents, who raised him. Noel Conaway loved to yank radishes and pearl onions from the ground, wipe them on his shirt, and pop them into his mouth. And Joann Conaway loved to rib him about it. "Dag gummit, Noel," she'd say. "You stink!"

Four months later, Grant sat inside the Boston office of Freight Farms, a company that retrofits windowless freight containers—the kind you see cruising down the interstate on eighteen wheels—

into farms. He stared at a United States map marked with the number of farms the company had sold in each state. Outside of Florida, the entire Southeast was blank. He combined his savings with a business loan from a local bank, purchased two container farms, and had them delivered to Joann's backyard in Guyton, Georgia, 300 yards from the half-acre plot he grew up tending.

When Grant's cousins came to help, Joann joyfully returned to the to the role she'd played when they were young. She made sandwiches and sour cream pound cake and fussed at them if they got too busy to come to the house and eat.

Grant knew he was onto something, but he needed help. The farms he purchased came with the promise of plug-and-play success, but his butter lettuce did not grow at the rate the company advertised. None of the lettuce did. Grant, a Georgia Tech grad, was stumped—and scared.

"To the point of on my knees, in tears, some days because I had so much work ahead of me and I knew even if I got it all accomplished, I still wasn't going to be able to pay bills that month."

Joann climbed into the cab of her grandson's truck and rode with him to church group meetings where she'd arranged for him to speak. She'd set out pineapple sandwiches. He'd explain indoor farming. When a potential investor flew in while Grant was out delivering greens, Joann welcomed him in, proselytized soilless growing, and fixed him a slice of cake.

The investor signed on. Others followed. And then the director of economic development for the city of Metter, fifty miles west, called with a proposal: Would Grant move his farms there and anchor a new, state-funded, ag-tech-business incubator?

"WHAT YOU'RE LOOKING at is a science project," Grant says, two years after setting up shop in Metter. He extends an arm toward the containers that now fill one corner of the city's former public works garage, a metal-walled building that used to house vehicle parts, traffic cones, and buckets of hydraulic oil.

"I really thought I was starting a farm business, but we've spent a lot more time thinking about where we fit into the food industry," he says. "We

Freshly harvested romaine leaves wait to be packaged ahead of the day's deliveries at Better Fresh Farms in Metter, GA, February 2022.

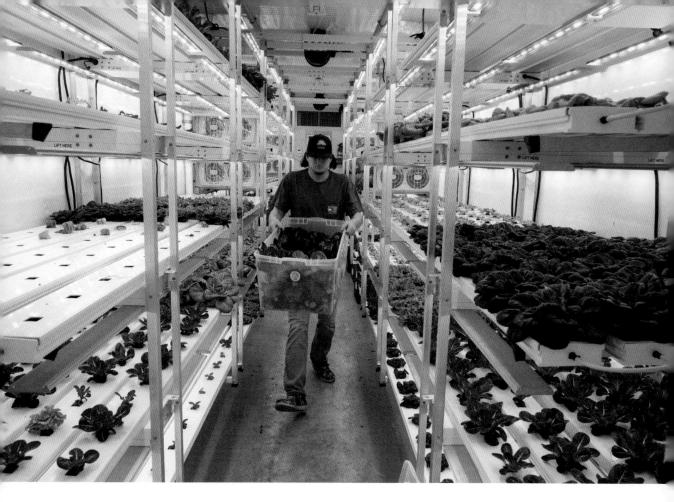

Colby Conaway harvests red leaf lettuce in one of Better Fresh Farms' container farms.

need to figure out how we can compete with the stuff from California."

Better Fresh Farms turns out eight types of lettuce, plus kale, collards, radishes, basil, Swiss chard, and bok choy. Grant knows that in order to secure funding to place these container farms in critical locations around the state, he needs to garner a reputation. He needs to become the lettuce king of Georgia.

"I've always wanted it to be collards, that's just the Southern boy in me," he says. "But telling people I have fresh collards in May is like fixing a batch of chili. It just doesn't seem to fit."

Which begs the question: What is lost when we engineer season and terroir? Indoor farms mimic the nutrients of soil types. Proponents argue that nutrition and flavor diminish by the hour after harvest, so a shorter path to market should be the goal. Hydroponic farms in the South translate to fewer food miles, less wasted water, and reduced chemical runoff to rivers and lakes. But they also use electricity. "Over time, the goal is a net-zero operation," Grant says, which he plans to achieve via composting, solar power, and more efficient HVAC and LED systems.

When done right, row cropping with regenerative land practices achieves similar results. But on a practical level, it can be hard for farmers to square the long-term benefits of regenerative agriculture with the short-term demands of the market. "We use as little as we can to let [the plants] do the best they can," Grant says. "It's a direct contrast to what traditional farmers are forced to do now to get a marketable product. It's not to knock them. It's just where we are."

Grant walks from container to container, talking pH and nutrient content and recounting front-line tales, like the time he rushed over at 2 A.M. to repair a broken water pump. Then he starts to tell his own story.

"I don't eat a lot of homemade food anymore," he reveals. "My wife and I cook when we can, but not like Grandma did." Every couple of years, Joann makes a somber announcement. Something like, "I'm not making jelly anymore," or, "This is my last batch of pickles." The family recipe version of Marty McFly's fading sibling photograph.

"That really hurt my heart over the years,"

Grant Anderson, founder of Better Fresh Farms, on a delivery run to a local golf club.

Grant says. "A lot of people love her who barely know her because they ate something she cooked and could tell she cared when she cooked it."

He remembers Joann driving to his high school with a pot of chicken and dumplings to feed the basketball team before their games. The way she flavored and fortified white rice with leftover ham stock. The way she playfully scolded Grandpa Noel about reeking of raw onions and radishes.

Those memories stick with Grant. So do the memories—harder ones—of time he spent in the finance industry. "I was responsible for a fore-closed real estate portfolio in my hometown. And I was responsible for selling property that, in some cases, my family had lost. There was a pit in my stomach. At times, I felt like what I was doing wasn't right."

"This," he says, tapping a palm to one of his original container farms, "almost immediately—even though it was different—meant something to me."

It was a radish that landed Better Fresh an important early client, Emporium Kitchen & Wine Market in Savannah's posh Perry Lane Hotel. On a Saturday morning in 2018, Grant manned a table of produce at Savannah's Forsyth Farmers Market. Bags of salad greens piled up next to a basket of D'Avignon radishes, a small French varietal. Andrew Wilson, then the executive chef of Emporium, approached the table. He'd been looking for that exact radish for a simple French breakfast dish he hoped to feature on the opening menu. He bought a bag and, when the restaurant opened, called Grant to lock in weekly deliveries. "It was certainly not the radishes my grandpa grew," Grant says. And Grant's not the backyard gardener his grandpa was, triumphantly munching his crop fresh from the dirt. But he is forging a path forward for local agriculture on a small patch of land in Georgia. Different, but the same. 🏆

Alison Miller is a freelance writer and editor in Athens, Georgia. She is a 2021 graduate of the Narrative Nonfiction MFA program at the University of Georgia and a part-time instructor at UGA's Grady College of Journalism and Mass Communication.

SPELLBOUND IN THE KITCHEN

Across the South, occult practitioners cook with a dash of magic.

BY NEELY MULLEN

HOME COOKS AND ENTHUSIASTIC EATERS alike understand well-loved kitchens and thoughtfully prepared meals to be more than the sum of their parts. In many Southern households, it's nearly impossible to avoid the cliché "cooked with love." The kitchen is often referred to as the "heart of the home." And for some women, this symbolic altar, and the alchemy that takes place there, is more than a metaphor—it's literal.

When Michelle Baker was growing up, kitchen magic was both sacred and quotidian.

"This kind of goes back generations in my family," Baker, who was raised in the Druid tradition, said. "It's just like if somebody was raised as a Christian, or as a Buddhist. So for me, I've always been taught this way."

Baker and her husband, chef Greg Baker, owned and operated The Refinery, a beloved Tampa restaurant, from 2010 until 2019. She is part of a community of people who self-identify as "kitchen witches."

For Baker, magic in the kitchen looks like a familiar prayer, a process worn smooth and fluid by years of repetition and intention.

"Even just knowing where every one of your ingredients is, it's like you could be blindfolded and cook in your own kitchen," she said. "That's your sacred space. And everything in it has purpose and meaning. You have your favorite burner. Have you ever noticed that? You have your favorite spoon…. I have probably over $25,000 worth of knives in my home, and I have one knife that I use all the time."

Kitchen magic, or conjure cooking, is an umbrella term for a diverse array of rituals that combine food with the occult. The term is shorthand for a myriad of individual, specific traditions practiced across the sprawling field of witchcraft and spirituality. These practices have been intertwined for generations in the South, and they are enjoying increased popularity and visibility today.

"Thousands of years ago, the hearth of the home was the kitchen, and it's where all the magic happened," Shawmarie Jeffery, owner of Mooringsport, Louisiana–based Inexplicable Things Apothecary, said. "They said their blessings there, they prepared food there. I mean, you name it, that's where it happened. The kitchen is a huge part of most magical traditions."

Just as an individual's religious and spiritual practices are influenced by her cultural background and personal perspective, kitchen magic

Illustrations by Lindsey Bailey

means something different for everyone who practices it. Jeffery grew up in a Pagan household, and for her, kitchen magic is more than just an isolated prayer. It offers an opportunity to connect her own energy to a larger cycle that communes with her ancestors and with the land itself.

"At least twice a month, usually on the new moon and the full moon, we give ancestral offerings and offerings to the land sprits. No matter where we live, no matter what we're doing, we stop and do that," Jeffery said.

While her husband, Kelly, focuses on conjure cooking for the couple, Shawmarie dedicates her practice to ancestral offerings. She pays special attention to her grandmother, who is deceased.

"They go hand in hand," she said of the food she and her husband prepare for both the living and the dead. "Except, for one, you're cooking for somebody to consume it, and for the other you're think about the offerings that you're going to lay out for your ancestors, as well as for the spirits that are near your home. People can give offerings to the land spirits anytime...and for their ancestors, of course. I have coffee with my grandmother three or four days a week, and she gets a cup of coffee. Kelly buys her flowers once a week. So she's happy."

A kitchen witch's rituals and intentions can vary widely. For some, like Shawmarie, food is used as a conduit for connecting with the land and one's ancestors. For witches like Baker and Abernathy Rose (a pseudonym), magic in the kitchen means adding a spiritual element to everyday meals prepared in the home.

"When you're putting rosemary on chicken, most people are just putting rosemary on the chicken and calling it a day," Rose said. "We're putting rosemary on chicken and we're holding it in our hands and we're blessing it. We're blessing it because, whoever eats this chicken, we want them to have a good year.... We're blessing it and we're talking to it like it's alive, right? So a lot of times, people will come over and they think you're crazy.... That's the difference [with] a conjure cooker. We're actually making a concentrated effort to bless these things."

Like Baker and Jeffery, Rose, who lives in North Carolina, says her practice is based in intention. However, her magical background differs greatly: For Rose, magic was salvation. After a childhood marked by tragedy and abuse, it gave her both an outlet to work through her trauma and power enough to change her circumstances.

"Unfortunately, it wasn't the love and light path that I started on, because that wasn't my life," she said. "It's tragedy after tragedy, it was about survival, it was about protecting myself. And it was about not letting anyone hurt me ever again anymore. And so I started dark."

After first embracing the darker side of magic, Rose began a journey that would lead her to study

> Kitchen magic can be a conduit to communing with one's ancestors. Or it can simply mean adding a spiritual element to everyday meals prepared in the home.

a variety of traditions until she carved her own niche. Rather than declaring herself a part of any one tradition, she settled on the title of occult methodologist to describe her multifaceted approach. And, although Rose has experience with several forms of elaborate, ceremonial magic, she says that the more intimate kitchen magic holds a special power all its own.

"The trick about conjure cooking is that you don't ever tell them you're doing it," she said. "It's done in secret. It's done in goodwill. And it's done in good hopes that whoever consumes this food is going to reap the benefits of the blessings you

put into it.... Conjure cooking is a really cool thing. And when you see the blessings manifest onto the people you've given them to, it's a really good feeling. "

Kitchen magic has been a way of life for long-time practitioners like Rose, Baker, and Jeffery. And awareness is growing online, providing budding kitchen witches across the globe with vast and thriving communities to explore different practices.

One cursory search on Facebook finds dozens of groups dedicated to conjure cooking, with names like "Kitchen Witches" (45,000 members), "The Witches' Kitchen" (10,000 members), and "Solitary, Eclectic Kitchen Witch" (27,000 members). This spike in popularity does more than spread the ideas of kitchen magic—to Baker, it's a modern version of ancient traditions.

"I love seeing so many younger generations interested in this," Baker said. "It's been a really great experience having an ability to share knowledge. For me, with my Pagan roots in that ancient Nordic tradition based on the Druids, there are no written documents from Druids. Zero. Everything was shared through storytelling. This is just kind of another fashion of storytelling."

The growing popularity and conversation surrounding the kitchen magic could inspire everyday home cooks to think more deeply about what makes food and cooking special. They might be attracted to the sense of power and possibility inherent in the quotidian act of preparing a meal, even if they don't want to self-apply the "witch" label.

"It's funny, because especially Southern cultures have always used it, they just didn't know it," Jeffery said. "That's what they were doing when they put so much love and feeling into their comfort food. It's being brought to the forefront of everybody's brains that, hey, this is kind of kitchen magic. And everybody does it."

Neely Mullen is an undergraduate student majoring in journalism and graphic design at the University of Mississippi. This article was made possible through a gift to the Southern Foodways Alliance and the UM School of Journalism and New Media by Susan Puckett.

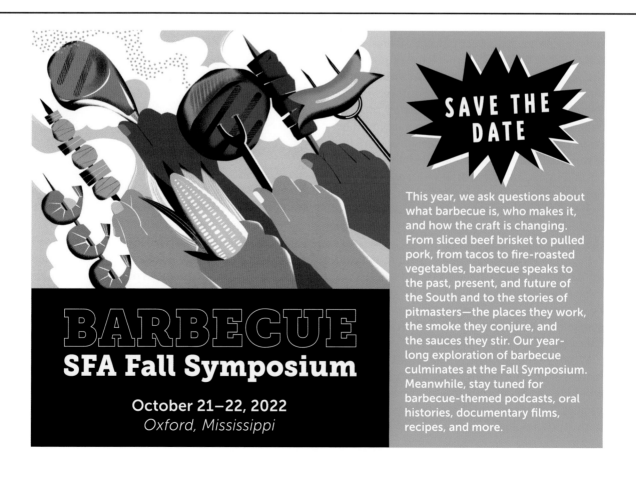

SAVE THE DATE

BARBECUE
SFA Fall Symposium

October 21–22, 2022
Oxford, Mississippi

This year, we ask questions about what barbecue is, who makes it, and how the craft is changing. From sliced beef brisket to pulled pork, from tacos to fire-roasted vegetables, barbecue speaks to the past, present, and future of the South and to the stories of pitmasters—the places they work, the smoke they conjure, and the sauces they stir. Our year-long exploration of barbecue culminates at the Fall Symposium. Meanwhile, stay tuned for barbecue-themed podcasts, oral histories, documentary films, recipes, and more.

SPINNING GOLD OUT OF CHAFF

SFA documents baking traditions.

BY ANNEMARIE ANDERSON

STEAM CURLS AROUND JOYE B. MOORE. Her arms protected by industrial oven mitts, she carefully ladles cooked sweet potatoes from boiling water. When they cool, she peels the skin to reveal the deep orange flesh, the star of her sweet-potato pies. Moore is a narrator in the Southern Baking Project. In late 2018, SFA's oral history program began collecting interviews for what would become the Southern Baking Project. As SFA's oral historian, I was curious about the ways in which people—particularly women—throughout the South have used their baking skills to make a living. Baking businesses, often informal and home-based, have existed for generations, and they continue to flourish.

Baking played an important economic and communal role in the small Florida town where I was raised. Like many people, I grew up surrounded by school bake sales, pound cakes at wakes, and a neighborhood cake lady who sold Italian cream cakes out of her home kitchen.

When two pastry chefs walked into my oral history workshop a few years ago, I knew they would be excellent collaborators to carry on the project. Kelly Spivey and Sarah Adams were graduate students and self-taught bakers who had each worked in professional kitchens. Thanks to their deep knowledge of baking practices, they brought passion and nuanced perspective to their oral history work.

As a historical topic, baking often lies on the fringes. Maybe that's because it's been seen as women's work. Maybe it's because we see dessert as lagniappe. Yet baking is alchemical. Simple elements of flour, butter, sugar, salt, and eggs are turned into joy, sustenance, and economic freedom. Bakers spin gold out of chaff when they transform these ingredients into a flaky biscuit or

Julia Rendleman

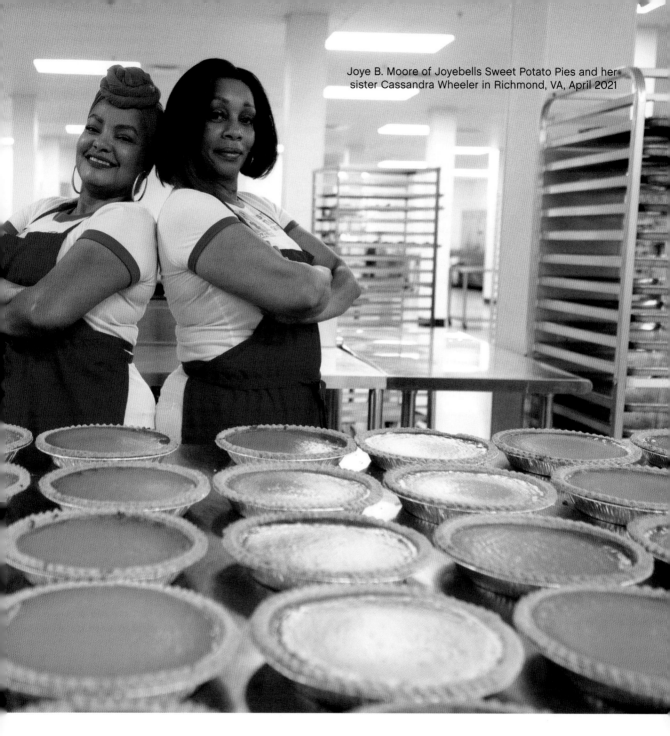

Joye B. Moore of Joyebells Sweet Potato Pies and her sister Cassandra Wheeler in Richmond, VA, April 2021

Generations of Southern bakers have used their expertise to claim a space for themselves in a society that hemmed them in because of their gender or the color of their skin.

an elegantly latticed fruit pie. For bakers in the past and the present, goods like pies and cookies are a sweetness that transforms everyday drudgery into sublime existence—and sometimes into an independent income. Generations of Southern bakers have used their expertise to claim a space for themselves in a society that hemmed them in because of their gender or the color of their skin (and, more often than not, a combination of the two). Narrators Joye B. Moore and Evva Hanes built businesses on generational recipes.

Joye B. Moore's sweet-potato pie recipe has

been made by six generations of women in her family. Moore inherited her recipe from her great-great grandmother, Nannie Mae Middleton. She remembers her backyard in Goldsboro, North Carolina, as a place filled with food. Middleton had chickens, pecan trees, and a huge garden. She even carried salt and pepper in her apron to sprinkle on fresh summer tomatoes.

Moore also remembers her grandmother's kitchen as a site of comfort and self-sufficiency for the women in her family. As a child, Moore watched her grandmother bake sweet-potato pies for family celebrations or community events.

When she was laid off from her nonprofit job in Richmond, Virginia, in 2019, Moore faced a difficult decision. She was fifty-six years old. Did she try to find a new job and start over, or did she draw on the strength she found in her great-great-grandmother's kitchen and take a chance baking for a living? Moore took her family's sweet-potato pie recipe and started to bake. She began selling

her home-baked pies at farmers' markets and Richmond's Dairy Bar Diner under the name Joyebells. They were an instant hit. Moore's business grew. She rented commercial kitchen space. Just as multiple generations worked together in her grandmother's kitchen, her sister and her daughter now help keep up with demand.

"I know that I won't be…that older woman who's doing something she doesn't want to do just because she has to live," Moore said. "I see an alternate ending to that, and pies are that for me." Moore's freedom, energy, and autonomy emanate from her baking knowledge, like the five generations of women who came before her.

Evva Hanes, owner of Mrs. Hanes' Moravian Cookies, also built her business on generational skill. She was born Evva Foltz, the youngest of seven children, on her family's farm in 1932. She was raised in Clemmons, then a rural community just outside Winston-Salem, North Carolina, and her family had deep Moravian roots. She learned how to bake her sugar crisp cookies from her mother, Bertha Crouch Foltz, who would bake and sell the cookies to supplement farm income. Her mother's sugar crisp cookie recipe, a modified version of the traditional ginger flavor, jumpstarted Hanes' business in 1960.

The business has gradually grown throughout the years. Mrs. Hanes' Cookies grew to employ family members, and eventually, they needed even more help mixing dough and baking cookies. "We made all we could make and sold all we could make, and every year we'd make a few more, and we've been blessed beyond measure," Hanes said. Today, their bakery in Clemmons remains a source of employment for dozens of community members. Mrs. Hanes sells millions of cookies a year, each rolled out and cut by hand. Her bestseller is the quintessential Moravian cookie, wafer-thin and traditionally flavored with ginger and molasses. Spivey was impressed with the care and sheer labor that goes into baking all of those cookies. "We like to romanticize making everything by hand, but it was really hard," Spivey told me later, reflecting on the labor and infrastructure it takes to make the sugar crisp cookies.

LEFT: (Above) A package of Mrs. Hanes' Moravian Cookies, which are rolled and cut by hand (below) before baking. RIGHT: Evva Hanes outside her home in Clemmons, NC, April 2021.

Kate Medley

Bakers spin gold out of chaff when they transform
ingredients like flour, butter, sugar, salt, and eggs into
a flaky biscuit or an elegantly latticed fruit pie.

A few months after the interview, Evva Hanes sent me a handmade card, carefully decorated with dried violas. It still hangs in my office. In it, she thanked Spivey and me for the bound transcript, audio, and images that we sent her, and she updated us on her life and work since Spivey first interviewed her. Below her card hangs a printed photo of Joye B. Moore and her sister Cassandra Wheeler, smiling in front of a work table full of freshly baked pies. When Adams and Spivey first conceptualized their baking interviews in late 2019, none of us knew that we would be interviewing people on Zoom or masked and distanced in open spaces. We imagined this project to be a wide-reaching, meandering collection filled with voices of many bakers throughout the South. We would spend the summer traveling the region,

learning about baking traditions and innovations. Instead, I worked with Adams and Spivey as they honed their interviewing plans, pivoting with every new roadblock they encountered. To conduct their work safely, they had to concede some of the face-to-face intimacy that is a hallmark of oral history—and one of my own favorite aspects of the work. I think of this persistence every time I turn to the wall in my office where both Hanes' card and Moore's photo hang.

We've learned together that narrators like Moore and Hanes teach us more than the importance of well-tested traditional recipes. They remind us that sometimes, the best thing to do in the face of a challenge is to hang on, develop our skills, and see our tasks through to the end. That's sweet work, indeed. ⚱

Annemarie Anderson is SFA's oral historian. By the time you read this, she'll be defending her thesis portfolio for an MFA in Documentary Expression from the Center for the Study of Southern Culture at the University of Mississippi.

In Memoriam

VALERIE J. BOYD (1963–2022) WAS A VERY GOOD EATER. AND A VERY good friend. For the past seven years, we gathered often at well-laid tables for wide-ranging conversations. In Athens, where she directed a narrative nonfiction writing program at the University of Georgia, and where she convened our mentor group at Seabear for mock arguments over student assignments and round after round of oysters on the half shell. In Oxford, where she served the SFA as a board member, and where, during one of our symposia, she conspired with chef Mashama Bailey to tell the story of author Zora Neale Hurston through a menu that ranged from roasted rabbit to smoked whiting. (If you have not yet read *Wrapped In Rainbows*, Valerie's biography of Hurston, today is the day to right that wrong.) And in Birmingham, where Valerie gathered friends at Highlands or Bottega or Chez Fonfon to talk with Pardis Stitt and eat slices of coconut cake baked by Dolester Miles. Valerie led by writing well and teaching well and caring fiercely. She showed us all profound new ways to join together and be together and work together. We mourn our loss and celebrate her too-short life. Valerie was our sun, shining with joy and possibility. Those of us who called her friend were very lucky to spin in her orbit.

<div align="center">

JOHN T. EDGE
Photograph by Pableaux Johnson

</div>